D1344810

IMPRESSIONIST AND MODERN MASTERS IN DALLAS

Monet to Mondrian

by Richard R. Brettell

Dallas Museum of Art

This catalogue is sponsored by a generous grant
from Carol and George Poston.

EDITOR
Robert V. Rozelle

CHECKLIST PREPARED BY
Susan J. Barnes,
Natalie Lee,
Debra Wittrup

PHOTOGRAPHY
Tom Jenkins

DESIGN
Lidji Design

DESKTOP COMPOSITION
The Fuld Group

COLOR SEPARATIONS
Webb & Sons, Inc.

PAPER
Clampitt Paper

PRINTING
Hurst Printing Co.,Dallas

Exhibition organized and presented
September 3 – October 22, 1989 by
The Dallas Museum of Art

The Dallas Museum of Art is supported, in part, from funds from the Division of Cultural Affairs, Dallas Park and Recreation Department.
This project is also supported by a grant from Texas Commision on the Arts and the National Endowment for the Arts. A portion of the
Museum's general operating funds has been provided through a grant from the Institute of Museum Services, a Federal agency that offers
general operating support to the nation's museums.

This exhibition celebrates a generation of distinguished art collecting in Dallas – a generation that coincides with the era of greatest prosperity and international economic stature in the history of the city. During the past thirty years, men and women from Dallas have calibrated their aesthetic judgment in a world-wide arena, vying with collectors in America, Europe, and Asia for masterpieces of Impressionist and Modern European painting. In that time, they have assembled what might be called a "collective" collection that we are now presenting at the Dallas Museum of Art as part of the Dallas Arts District's celebration of the opening of the Morton H. Meyerson Symphony Center.

One might think that Dallas collectors were a little too late to enter the hyperanuated market of Modern Art and that, as a direct result of their late entrance, they would have been forced to buy "minor" works not already seized by the collectors and museums of the late 19th and early 20th centuries. How much easier it would have been, for example, to buy Post-Impressionist masterpieces in the 1920s when Frederick Clay Bartlett paid $25,000 for Seurat's masterpiece, *Sunday Afternoon on the Island of La Grande Jatte*, now at the Art Institute of Chicago, or even in the thirties and forties when many of the now legendary collections in Switzerland were formed.

Yet, if Dallasites were too late entering the Modern Art market, how does one explain the extraordinary richness of this city's holdings of Impressionist and Modern Masters? How does one account for the fabulous group of Impressionist landscapes, still-lifes, and seascapes? For the sensational paintings by Bonnard and Rouault? For the superb Fauve landscapes? For the Mondrians, the Braques, and the provocative group of Soviet Avant-Garde paintings from the decade following the Russian Revolution? And the question becomes even more insistent when asked about major works by Manet, Boudin, Pissarro, Vlaminck, Bonnard, and others which have been purchased for private collections in Dallas only in the past two years. As a city, Dallas has done very well in the international art market.

Dallas collections of modern painting were first recognized "officially" in 1978, when the then Dallas Museum of Fine Arts under the brilliant curatorship of Dr. William B. Jordan organized an exhibition on the very same principles as this one. In it were 97 paintings, 29 of which belonged to the museum and 41 of which constitute once again a core of the loans to this exhibition. Since 1978, the museum's permanent collection has grown enormously primarily as a result of the most important event in the history of the museum's own collecting of French painting, the gift of the Wendy and Emery Reves Collection in 1985. Meanwhile, Dallas collectors have also continued to make significant additions to their holdings, so that the present exhibition contains over 70 major works of art that were not even in Dallas ten years ago. When one stops to consider that there are numerous other major works which for various reasons we were not able to include in this exhibition, and that others undoubtedly exist but are unknown to the staff of the museum, the real brilliance of Dallas collectors becomes even more clear.

We intend this catalogue to serve as a comprehensive handbook to the public and private collections of modern European art in Dallas. In it are color repro-

ductions of all the works loaned to the museum from private collections as well as the first published checklist of the museum's own extensive holdings, illustrated in black and white. The combined holdings of the private sector and the museum, especially with the superb paintings and drawings in the Wendy and Emery Reves Collection, are truly breathtaking. Even a simple count of important works by major artists is impressive. There are, for example, seventeen works by Mondrian, fourteen by Pissarro, thirteen by Monet, ten by Renoir, and Bonnard. There are eight by Redon, seven by Sisley, six each by Manet, Cézanne, Rouault and Léger; and five by Vuillard. A visit to the exhibition followed by a thoughtful tour of the Reves Collection should make clear what the catalogue documents – that Dallas, Texas is a very good place to study and enjoy Impressionist and Modern European Masters.

Impressionist and Modern Masters in Dallas, like all exhibitions, is the work of many in the museum, and chief among them were Susan J. Barnes, Senior Curator of European and American Art; Tom Jenkins, Museum Photographer; and Natalie H. Lee, Volunteer Research Associate; Debra Wittrup, Exhibitions Assistant. Among other staff members whose enthusiastic response to this exhibition have contributed significantly to its success, let me especially thank: Melissa Berry, Special Programs Coordinator; Nancy Berry, Public Programs Director; Anne Bromberg, Research Curator and Scholar in Residence; Heidi Bruster, Assistant to the Director; Eileen Coffman, Manager of Visual Resources; Jody Cohen, Assistant Registrar, Loans and Exhibitions; Gail Davitt, Coordinator, Docent Program; Barney Delabano, Curator of Exhibitions; Amy Gilchrist, Museum Buyer; Scott

Hagar, Photography Assistant; Aileen Horan, Museum Educator, Gateway Gallery; Lynn Jones, Visual Resources Intern; Anna McFarland, Exhibitions Coordinator; Judy Nix, Director of Development and External Affairs; Carolyn Perot, Curatorial Intern; Bob Rozelle, Director of Publications; Amy Schaffner, Librarian; Liza Skaggs, Assistant to the Director; Pam Wendland, Marketing Manager; and Melanie Wright, Public Relations Manager. Thanks are also due to a number of individuals outside the museum who have kindly answered questions and supplied helpful information. These include: Vivian Endicott Barnett; Bruno de la Croix Vaubois; Carolyn Burns Foxworth; Ay-Whang Hsia; and Steven A. Nash.

We owe our greatest thanks, of course, to the lenders. Their generosity to this exhibition is, in my experience, without parallel. I can think of no occasion in which so many lenders, some with two or three paintings and others with more than a dozen, have virtually emptied their homes for the benefit of the public. The people of Dallas and our visitors from around the world can be very grateful for their magnificent acts of sharing. There is, of course, a sense of civic pride in this exhibition, because the Dallas Museum of Art is joining in the celebration of the Meyerson Symphony Center on the occasion of its grand opening. Together, the Meyerson and the Dallas Museum of Art, as well as the Dallas Theater Center's Arts District Theater, stand as living symbols of the vitality and brilliance of the arts in Dallas and of the City's commitment to the public support of arts.

Richard R. Brettell

Director

Is there anything left to say about Impressionism?

After a visit to any bookstore, museum shop, or art library, one could reasonably ask this question. John Rewald's brilliant *History of Impressionism*, first published in 1946 and republished ever since in abridged and improved form, has been a fountainhead for a veritable industry in art publishing. In the past five years alone two new critical histories of Impressionism have been published, one by Robert Herbert of Yale University and another by Timothy Clark of the University of California at Berkeley. There have also been four major monographs and an important catalogue raisonne devoted to Monet, and countless exhibition catalogues and picture books have created in the publishing industry what has been called the Monet "graphic traffic." The same could be said of Degas, Pissarro, Renoir, and their followers: Gauguin, Cézanne, and Seurat. Even Sisley, Morisot, Caillebotte, Guillaumin, and the lone American, Cassatt, have been honored by the publication of catalogues and monographs. And recent exhibitions in Ann Arbor, Michigan and Washington have brought more obscure Impressionist artists to the surface.

What might the scholar or amateur who troubled to read this flood of texts learn from them? Fortunately, the answer is a great deal. A generation ago, Impressionism was considered, even on university campuses, to be a kind of naive, "optical" art, one in which painters directly transcribed their sensations onto canvas in front of nature. Its function in the larger history of modern art was believed to be transitional at best. The movement was thought to have served as a liberator of artists from the shackles of the Academy and "dead" systems of culture in preparation for a truly modern art based upon considered principles. According to this view, the Impressionists tilled the field that

was later sowed by their great pupils, Cézanne, Gauguin, and Seurat, each of whom attempted to define a new aesthetic based upon an analysis of form and color. These artists, in turn, acted as formative influences on early 20th-century art, with Gauguin standing firmly behind Matisse and the Fauves in their liberation of color, while Cézanne and, to a lesser extent, Seurat acted as the artistic fathers of the Cubists, Picasso and Braque.

This was essentially the system of modern art as codified on both sides of the Atlantic in the first three decades of the 20th century. The German historian and critic, Julius Meier-Graefe, was the most important theorist of this generational and progressive history, which he outlined in his insightful work, *Modern Art*, first published in German in 1904 and in English in 1908. In England, the major voices belonged to Clive Bell and Roger Fry, and America produced its two greatest critics in the '20s, Sheldon Cheney, whose *Primer of Modern Art* of 1923 remains as important in the history of American modern art as does the better known writing of Alfred Barr, founding Director of New York's Museum of Modern Art. The great edifice of modern art created by these men was essentially a theoretical construct, based on looking at and thinking about art rather than on historical research. It was supplanted in the years after World War II by a new kind of history, of whom John Rewald was the father. For Rewald, it was not enough to theorize about modern art. Rather, it was the duty of the modern writer to delve into the historical record and to document in detail the precise formation of the Impressionist and Post-Impressionist movements, using archives, records, and documents as persistently as earlier writers used works of art as their sources.

From Rewald, we learn little about the theory of modern art. But we do learn about the daily lives of the Impressionists, about their struggles to become masters of their own artistic destiny, about the failures at the hand of critics of self-defining group exhibitions, of their difficulty in making ends meet, and, finally, of their heroic persistence in the face of adversity. In place of an idea of art based upon formal principles, Rewald and others presented us with a movement of artists whose lives were exemplary and important. Rewald tells us about Pissarro's left-wing politics, Cézanne's wealthy father, Monet's mistress, Sisley's carefully sheltered family life, and Renoir's search for an anti-industrial aesthetic in the midst of the Industrial Revolution. Where the Impressionism of Meier-Graefe, Fry, Bell, Cheney, and Barr was a mere step in the history of Modernism, Rewald's Impressionism was as worthy of close historical study as was any war, monarchy, or political movement. For Rewald, Impressionism *was* a part of history.

Rewald's idea has persisted in the writing about Impressionism to this very day. The greatest recent contributions to our thinking about the movement have been made by careful historians who have read and reread documents, scoured archives and libraries for unpublished source material, and integrated Rewald's daily history of Impressionism into the larger rhythms of the economic, social, political, and intellectual histories of modern France. Robert Herbert, in particular, in his stunningly detailed history of Impressionism, treats the movement as a part of what conventional historians refer to as the "new" Paris. With Herbert as a guide, we are treated to a carefully integrated analysis of the Impressionists' subject and style, both of which he maintains had fundamentally

social origins. From Herbert, we learn about the way in which art was part of a modern, urban consciousness, a consciousness that ran the gamut from the professionally managed bordellos drawn by Degas, to the upper-class resorts frequented by Monet and Manet. This new Paris of the Impressionists had little to do with the historical Paris of lore. Notre Dame and the Pantheon are present only "in passing," relinquishing their pride of place to cafes, department stores, restaurants, theaters, parks and circuses. For the Impressionists, the symbol of the city was the boulevard, not the palace – the train station, not the cathedral – and their seemingly direct and "sketchy" style was a carefully constructed system of modern artistic writing, as contemporary as were its subjects.

Herbert's colleague, the English art historian, Timothy Clark, has written extensively about the social and political content of Realist and Impressionist art, using as his hero Manet, the artist who never exhibited with his young colleagues, but who followed their movement carefully. In his most recent book, written while teaching at Harvard University, Clark combines a formidable knowledge of linguistic and Marxist theory with his energetic research into primary historical documents, and, if the art seems sometimes to get lost in the crossfire, the results are so brilliant and thought-provoking that they are worth the effort.

These two men, more than any other followers of Rewald, are the sources most responsible for creating the new history of Impressionism. Through their teaching at major universities as well as through their writing, they have spawned the next generation of scholar-teachers, most of whom are busily doing primary research and rewriting the history of modern art. Indeed, the field of modern European painting,

particularly between 1848 and 1930, has become the most active in the history of art, replacing the Italian Renaissance as the field of preference for new work. From their students, we have learned about the geography of Monet's and Pissarro's landscapes, about the cunning and completely artificial painting style of Monet, about the highly mediated relationships between art and political ideology in France, and about the intellectual world of modern artists.

As is evident from these paragraphs, the "new" Impressionism is a good deal stronger on university campuses than in museum galleries. In fact, there has been a real aversion to this profoundly social Impressionism on the part of museum professionals. For this reason, viewers to world art museums are presented through their publications, tours, and labels with a model of Impressionism that is little different from the one available to their grandparents before World War II! For most visitors, Impressionists are still relatively naive transcribers of pleasant scenes from nature. The persistent "museum" Monet worked directly from nature, avoiding the studio like the plague, while today's "academic" Monet developed a highly complex mode of painting with a good deal of work in the studio and with lengthy periods of reflection between bouts of painting. It is scarcely an exaggeration to say that the "museum" Impressionist and the "academic" Impressionist are almost opposite from one another.

Which, one may ask, is the "real" Monet? The answer is quite definitely the "academic" Monet. We know, for example, that the real Monet used black, though we are often told in museums that he never did. We also know from careful analysis of his paintings that they were begun out-of-doors, but finished, more often than not, in the studio, usually after lengthy

periods in which the earlier layers of the paint dried. We are often told in museums that the Impressionists cared little about the subjects of their paintings, choosing them more or less at random without concern for their meaning. Yet, any careful student can see clearly that each of the artists had decided personal preferences for landscape sites and that there is a good deal of "content" as well as "form and color" in Impressionist paintings. The belief that subjects were important to the Impressionists applies both to the urban figure paintings of Degas and Renoir and to the suburban landscapes of Monet, Pissarro, and Sisley.

The academic search for content in modern painting has gone considerably further than the work of the Impressionists. Advanced students of the work of Cézanne, Seurat, and Gauguin have attempted highly successful interpretations of these modern artists' work, interpretations that could have scarcely been imagined in the early part of this century by Meier-Graefe, Fry, Cheney, or Barr. We know of the "hidden" subjects in the early "abstractions" of Kandinsky, of the political meaning of Picasso's important collages made before World War I, of the complex, polyvalent sources for the poses and imagery of Gauguin's paintings, and of the profoundly psychological symbolism in the works of Van Gogh and Cézanne. The simple modern art of "form and color" that is still presented by most of today's art museums has become very complicated and richly rewarding in the hands of trained interpreters of modern art.

It is tempting to decry this new complexity, to wish for a simpler age when we all knew what to say in front of every painting. Yet, such a temptation must be avoided. The works of art themselves have proven to be too great to be simple. We must also avoid the

comforting thought that the "mystery" of a work of art is lost when we begin to interpret it. In fact, exactly the opposite is true. When a work of art is truly important, it becomes richer as one attempts to analyze it. The act of interpretation itself is as important for an Impressionist landscape painting, a Post-Impressionist figure painting, or a seemingly abstract Cubist painting as it is for a work by Leonardo, Rubens, Rembrandt, Chardin, or Delacroix. *Impressionist and Modern Masters in Dallas* provides visitors to the Dallas Museum of Art with ample opportunity to broaden their own responses to canonical works of modern art. Rarely if ever before in Texas have museum visitors been able to confront as large, complex, and important an assembly of actual works of modern art than in this exhibition. Opportunities for interpretation – or what might be called intelligent examination – abound at every turn of the installation. Due to the fact that there is such an abundance of brilliant critical and historical work already in print, this catalogue is not intended to serve as an interpretive guide of the works of art in this exhibition. The book store is full of texts for the assiduous visitor to peruse or purchase for future study.

The subtitle of the exhibition, *Monet to Mondrian*, might seem odd to a person who scans the plates in this catalogue and sees important works by Daumier, Corot, Manet, Courbet, and even Constable, most of which were painted before the works by Monet in the same catalogue. Yet, the title captures the greatest strengths of the collections – works by Claude Monet and Piet Mondrian. With thirteen paintings by Monet dating from the late 1860s to the early decade of the 20th-century, and with seventeen works by Mondrian, most of which were made before Monet's death in 1926 and one of which was finished

in the United States during World War II, the Dallas Museum of Art is temporarily a major center for the study of modern art. Only four cities in America can surpass this presentation in the work of the prolific Monet, and none can rival the museum's present installation of Mondrian.

Oddly, yet appropriately, it is with the work of Mondrian that the installation of the present exhibition begins. As a young artist, Mondrian was first swayed by the example of the Hague School, whose work was affected by the Impressionists and their parent movement, the Barbizon School. His early landscapes were painted rapidly, with a rich, buttery application of paint and a fascination with gesture. His imagery of trees rustling in the wind and reflected in water is a Dutch equivalent to that of Monet, Renoir, and Sisley. The second stage in Mondrian's development as a painter shows clear evidence of his Post-Impressionist sources, the works of Van Gogh, Cézanne, and Munch. By 1908, however, Mondrian sought to create a form of art tied less to visual sensations than to certain principles of color and pictorial structure which had been worked out by other artists in the 1880s and 1890s. The great windmills of Holland, the dunes, houses, and trees were thus transformed by Mondrian into icons that throb with emotional intensity.

Yet, the works of Monet and his followers were not enough for the restless and highly intelligent young Mondrian, and his search for an ultimate art took him through Cézanne to Picasso, Braque, and Gris, whose works he studied, but never imitated directly, choosing instead to develop a form of Cubism as strong and personal as that of Picasso. Following Mondrian's relentless path of development, one next encounters the utterly pure geometric abstractions

invented by the artist and his colleagues after World War I. Never in the history of art has there been a more philosophical painting. Stripped of all narrative, reduced to pure line and color, these paintings were made for a new world, and they have a purity that has rarely since been equalled.

It is clear, even from this summary, that encapsulated in the art of Mondrian is the entire history of modern art. His "Impressionist" paintings may lack the verve and brilliance of Monet, Renoir, or even Pissarro, and the nervously painted draftsmanship of Sisley, and his "Post-Impressionist" works sometimes pale by

learn from this one will emerge not so much from the catalogue, but from the experience of the works of art themselves. Where in the world, for example, can one study two virtually identical Impressionist landscapes by Renoir, both of which were painted on an excursion with Claude Monet in 1873? When *The Duck Pond* entered the DMA with its fabulous companions in the Reves Collection in 1985, every scholar in the world knew from Rewald that it was related to an almost identical painting of the same motif painted by Monet. What few, if anyone, knew at the time is that Renoir painted two variants of this picture in 1873 and that the

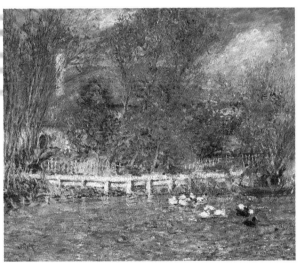
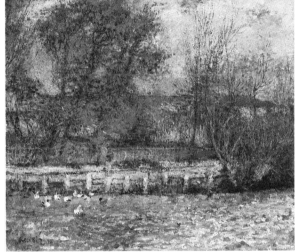

When the Renoir Duck Pond *(1873), far left, entered the DMA as part of the Reves Collection in 1985, most scholars knew that it was related to an almost identical work painted by Monet. What few, if anyone, knew at the time, is that Renoir painted two variations of this picture on his excursion with Monet in 1873, and that the other version, from a private collection and on loan to this exhibition, is also in Dallas.*

comparison with masterpieces by Van Gogh, Seurat, or Munch. Yet when one stands in front of *The Windmill at Blaricum* or *The Farm Near Duivendrecht*, the authority of the painting pushes aside all thoughts of comparison. Mondrian mastered every phase of Modernism before finding his own "true" art. Without his faithful, self-taught course in modern art, the world would be the poorer. It is, therefore, a particular privilege that we in Dallas can "enroll" in Mondrian's course in modern art simply by visiting the DMA's galleries and looking intelligently at his comprehensive, painterly record.

There are countless other treasures in *Monet to Mondrian*, and, like all great exhibitions, the lessons we

other version is also in Dallas! I know of no place else where a viewer can get closer to the pulse of a great Impressionist landscape painter than one can in Dallas when these two brilliant works are shown publicly for the first time in history.

There are many other great moments in the exhibition, including a group of ten landscape paintings from the 1870s, the most inventive and important decade in the history of Impressionism. This group includes major works by Monet, Renoir, Pissarro, and Sisley, all at the peak of their achievement and painted at a time in which their interaction as artists was as strong as it ever was. There are also single master-

pieces by Manet, Renoir, Caillebotte, Pissarro, and Sisley, each of which can stand as forcefully alone as it does in the company of equals. Caillebotte's *Rue Halévy Viewed from the Seventh Story* is as important a representation of modern Paris as anyone ever painted and communicates as powerfully to us about the alienation of the modern urban dweller from his fellow citizens as it does about the beauties of 19th-century Paris. Caillebotte's painting, like all masterpieces, is at once disturbing and profoundly beautiful.

The Bugler, a masterpiece by Manet from a private collection, joins the Dallas Museum of Art's *Portrait of Isabelle Lemonnier*, and the Kimbell Art Museum's superb *Portrait of Clemenceau*, which can be seen in nearby Fort Worth, to form a group of late figure paintings by Manet that is unrivaled in America. Although all three were left unfinished by Manet, remaining in his studio until his death, there is little doubt that *The Bugler* is the greatest work. All three isolate the figure in a simple setting, and all of them reveal the strength and subtlety of Manet's stroke and his attempt to exceed the great portraits of Velazquez, Rembrandt, or Goya – and each succeeds on its own terms. Yet, *The Bugler* is at once so strong and so maddeningly evasive that it sticks forever in one's mind. Who was this bugler? Why is he alone? Is he merely a model? What and for whom does he play? The painting, begun in the year of Manet's death, can be contrasted with another superb work from that year in the Reves Collection, the *Vase of White Lilacs and Roses*. While the floral still-life is a confection of freshness and subtle scents, *The Bugler* confronts the viewer as powerfully – and mysteriously – as do Manet's female figures of the 1860s, *Olympia* and the nude model in *Le Dejeuner sur l'Herbe*. Both the enigmatic *Bugler* and the floral still-life show us that Manet could be "young" even when he was old and ill.

Two major works of the 1880s are also worthy of mention. The iridescent and powerful *Wave*, painted by Renoir in 1882, is surely among the very greatest seascapes by that master, rivaling and probably exceeding the larger and more famous *Wave* of 1879, now in The Art Institute of Chicago. Renoir approached the subject in 1882 with the advantage of history, having just studied a major group of seascapes by Courbet included in that year's retrospective of the hallowed mid-century rebel master. After seeing Courbet's *Waves*, a particularly distinguished example of which is in the permanent collection of the Dallas Museum of Art, Renoir turned to the sea with a gusto and intensity absent in his earlier picture. The confident energy of his brushstroke is particularly evident in the 1882 *Wave*, because the painting has never been lined and thereby retains its original surface.

Another rarity worthy of pause is a major Gauguin, little known to Gauguin scholars and painted during his short, but very important stay in Martinique. We are fortunate to be able to study the picture in the original for two reasons: first, because it assumes its place in the newly evaluated career of that artist established by the major retrospective of 1988/89, and, secondly, because the world's authority on Gauguin's career in Martinique, Dr. Karen Pope, lives and works in Texas.

The early twentieth century is also richly represented in this Dallas showing. The group of Fauve landscapes rivals the Impressionist group in its completeness, with important paintings by Braque, Derain, Valtat, Vlaminck, and Marquet. These wildly colored canvases represent perfectly ordinary sites, many of

which had already been painted by the Impressionists and their followers. In this exhibition, we can compare them with exactly contemporary landscapes by Monet and Cézanne, as well as with works by non-French artists such as Mondrian, Munch, Kandinsky, and Kirchner.

The major paintings by Bonnard in Dallas attest both to the importance of that painter in the larger history of modern art and to the fact that the Dallas Museum of Art was directly involved in the great Bonnard exhibition presented in 1984 in Paris, Washington, and Dallas. Yet, even in this group, there are two little known paintings. The larger is a major landscape of 1917, which depicts a village on the Seine crowned by the ruins of a famous castle built by Richard the Lion-Heart of England. Here, Bonnard confronted history, and daily life more forcefully than most of the Impressionists. The second painting is a subtle early cityscape of 1897, which, when compared with a brilliant full-scale pastel by Vuillard executed in preparation for a large decoration, shows us the ways in which the young artists of the Nabis group dealt with the city of Paris. How different these cityscapes are – how much more crowded, human, and intimate – than the cityscapes by Caillebotte and Pissarro which are also included in the exhibition.

If *Impressionist and Modern Masters in Dallas* begins with Mondrian's patient search for a purely modern art, it also includes another, and fundamentally different kind of abstraction. This time, the setting is not the Europe we have studied, but the Soviet Union; not an isolated artist like Mondrian, but a group of aesthetic "comrades" who worked together in a way analogous to the Impressionists. We are fortunate that the Dallas Museum of Art and two major collectors in

the city have been mindful of the burst of utopian art created in the years immediately following the Russian Revolution in 1917. It has always been difficult for Americans to understand the Russian Revolution. Unlike "our" revolution, it was fought on site, not across an ocean, against a powerful monarchy. And also unlike our revolution, it eventually resulted in a totalitarian form of government which, until recently, most Americans have rightly abhorred.

In viewing the brilliant abstractions and the "useful art" of posters and magazine covers which fill the Soviet section of *Impressionist and Modern Masters in Dallas*, we should remind ourselves that, before the oppressive regime of Stalin, the Soviet Union fostered the first Museum of Modern Art in the world; that its leaders considered artists to be an integral part of society; and that artists eagerly accepted that challenge. As we study the experimental works of Chashnik, Kagan, Kliun, Matiushin, Popova, Rodchenko, and Suetin, we must not blame the Russian Revolution for Stalin and his followers, and we should acknowledge that the stunning, if short-lived political experiments of Lenin and Trotsky had their aesthetic equivalents.

While the young Soviets were reinventing art in Moscow, Leningrad, and other Soviet cities; while Mondrian and his colleagues sought a "pure" art; while Léger created a new "democratic" and urban art for the world that was to emerge after World War I; while Kandinsky and Kupka developed theories of abstraction before, during and after that horrible war, other artists, many of them equally great, painted continuously, seemingly out of step with the world. Bonnard and Matisse shut out contemporary subjects to create an utterly contemporary art based on color.

Picasso and Braque broadened the boundaries of Cubism to encompass the great traditions of painting that other, more radical artists tried to subvert. And, finally, Rouault worked patiently toward a kind of moral art that pulls deep at the heartstrings of human experience, reaching back to the middle ages, the great age of faith, for its forms and meanings.

Dallas is fortunate to have in its collection several works by Rouault. This richness is an odd one, mostly because the art of Rouault has been largely overlooked in the past two decades. Once a hero, a lone, but seminal figure, he has become a marginal artist, rarely included in survey texts on the development of modern art, perhaps because the religious content of his art in a secular century is so strong and so obvious. There is little doubt that this reversal in his critical reputation is a temporary one. His paintings and drawings are simply too powerful and too demanding to neglect. His judges, clowns, prostitutes, priests, acrobats, and apostles burn into our memories, reminding us that, even if we live in a "new" age, the great questions of life can still be asked and remain unanswerable.

There is, indeed, a good deal left to be said about – and to see in – Impressionism. A patient study of actual works of art in conjunction with the books that attempt to explain them is the best way to understand that Impressionism, and the works of modern art that followed it, are essential and integral parts of our vital modern culture.

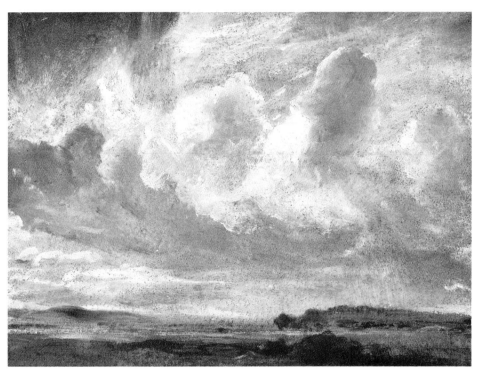

Plate 23. John Constable, *Cloud Study at Hampstead Heath*, 1820-1825?

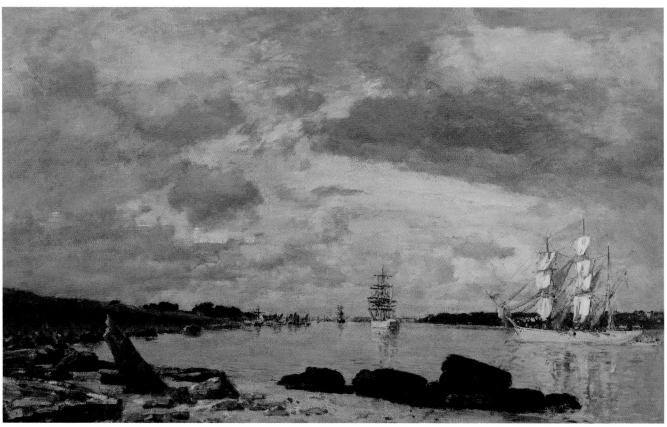

Plate 12. Eugène Boudin, *The Bay at the Mouth of the River Elorn, Landerneau*, 1871

Plate 11. Eugène Boudin, *Honfleur: Fishing Boat Leaving the Port*, ca. 1854-1857

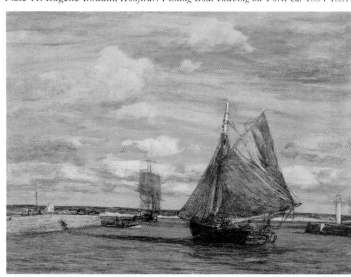

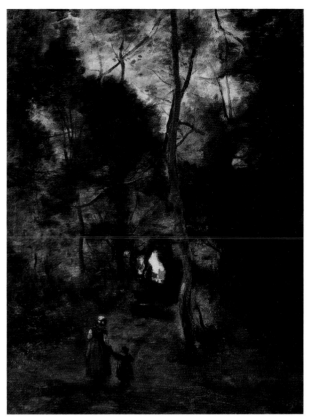

Plate 24. Jean-Baptiste-Camille Corot, *Semur, Path in the Woods*, 1855-1860, retouched 1873

Plate 25. Jean-Baptiste-Camille Corot, *Environs of Sevres*, 1870-1878

Plate 34. Henri Fantin-Latour, *A Corner of the Studio*, 1861

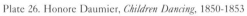

Plate 26. Honore Daumier, *Children Dancing*, 1850-1853

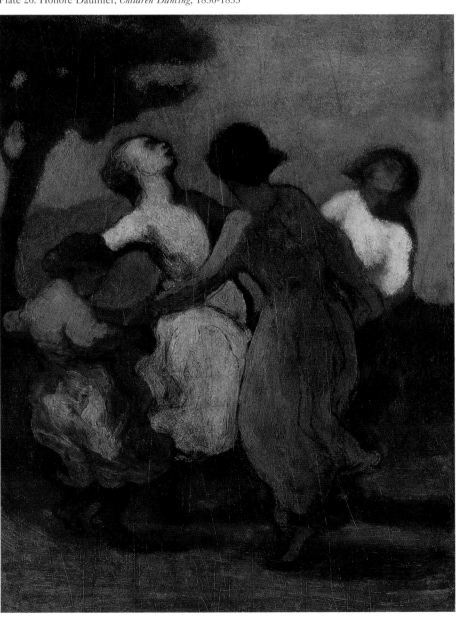

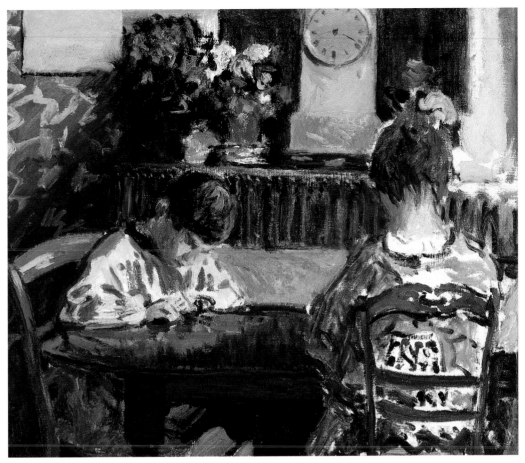

Plate 100. Alfred Sisley, *The Lesson*, 1871

Plate 50. Edouard Manet, *Profile of a Young Woman*, ca. 1880

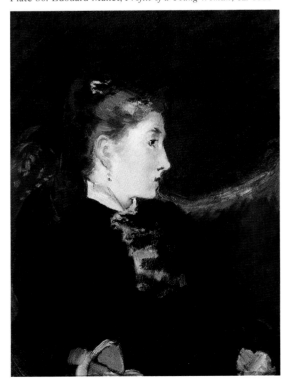

Plate 63. Claude Monet, *The Fête d'Argenteuil*, 1872

Plate 62. Claude Monet, *Village Street*, 1869-1871

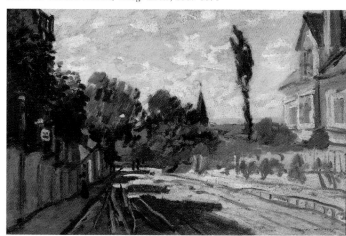

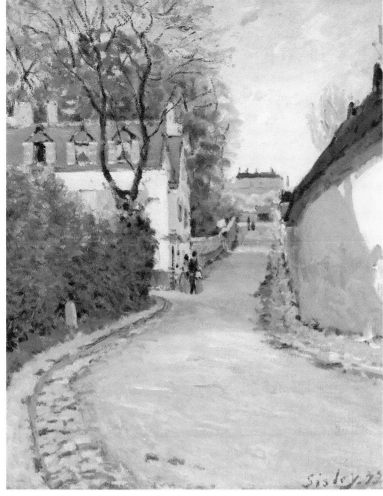

Plate 101. Alfred Sisley, *Street in Ville d'Avray*, 1873

Plate 77. Camille Pissarro, *View of Pontoise*, 1873

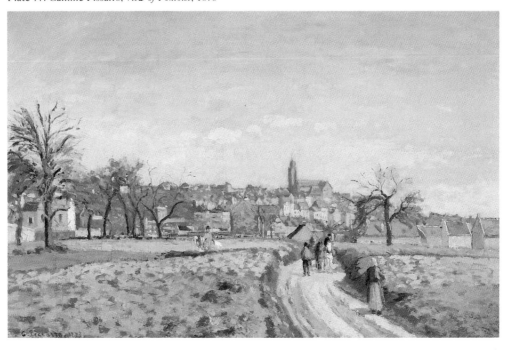

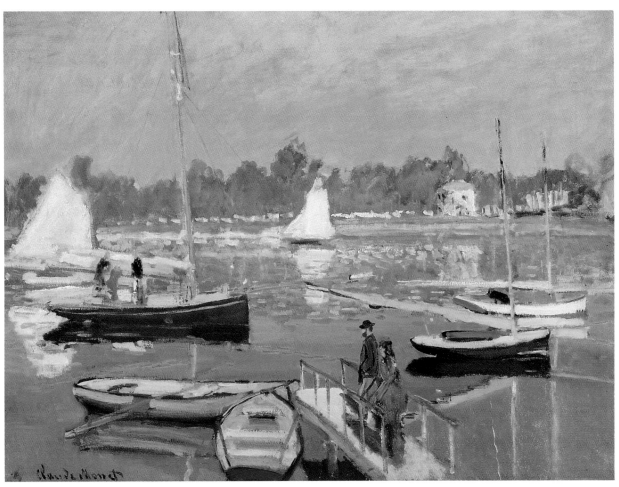

Plate 65. Claude Monet, *The Boat Basin at Argenteuil*, 1874

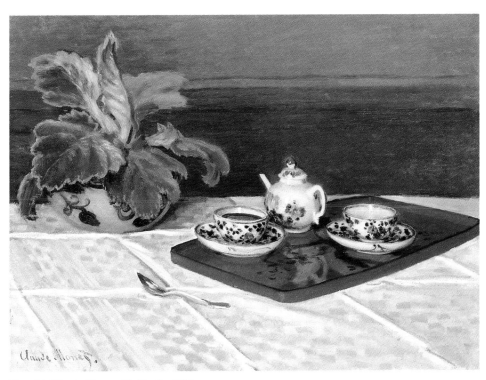

Plate 64. Claude Monet, *The Tea Set*, 1872

Plate 35. Henri Fantin-Latour, *Still Life with Narcissus*, 1881

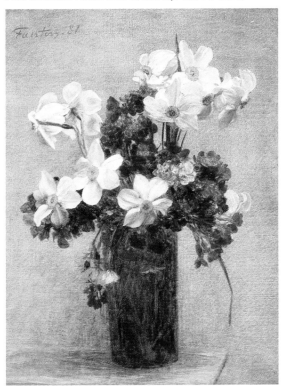

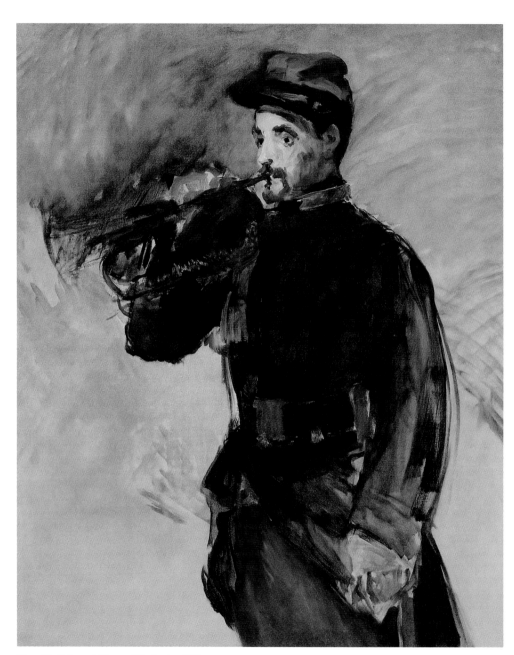

Plate 51. Edouard Manet, *The Bugler*, 1882

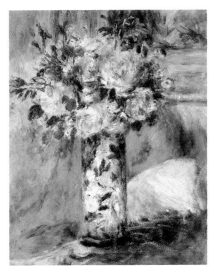

Plate 89. Pierre-Auguste Renoir,
Roses in a Vase, 1876

Plate 27. Edgar Degas, *Ballet Dancer with a Fan*, ca. 1879

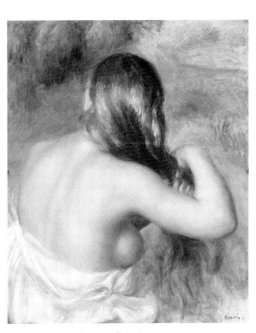

Plate 91. Pierre-Auguste Renoir,
Woman Combing Her Hair, ca. 1882-1883

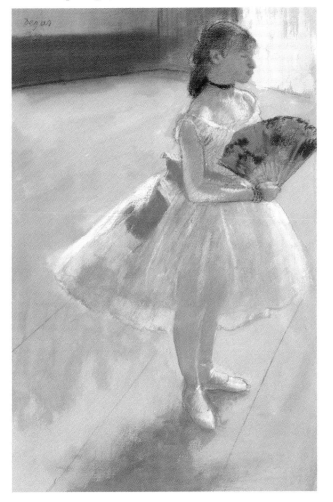

26

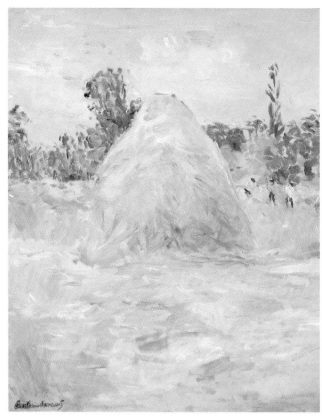

Plate 71. Berthe Morisot, *The Haystack*, 1883

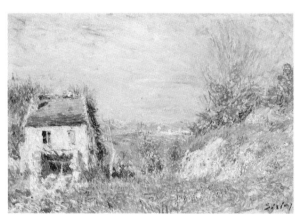

Plate 105. Alfred Sisley, *The Abandoned House*, ca. 1886-1887

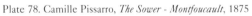

Plate 78. Camille Pissarro, *The Sower - Montfoucault*, 1875

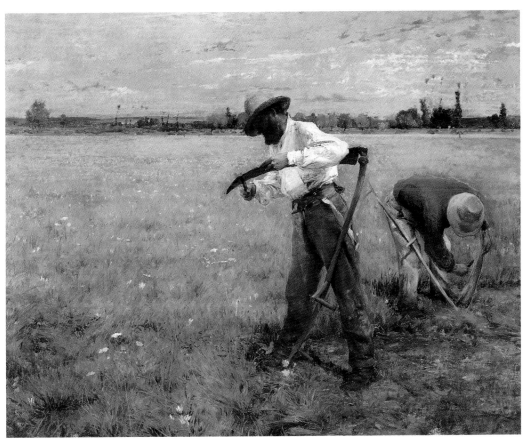

Plate 1. Jules Bastien-Lepage, *Sharpening the Scythe*, 1881

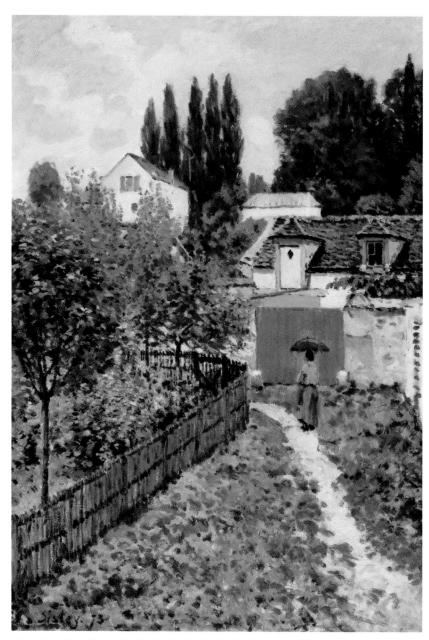

Plate 102. Alfred Sisley, *Garden Path in Louveciennes*, 1873

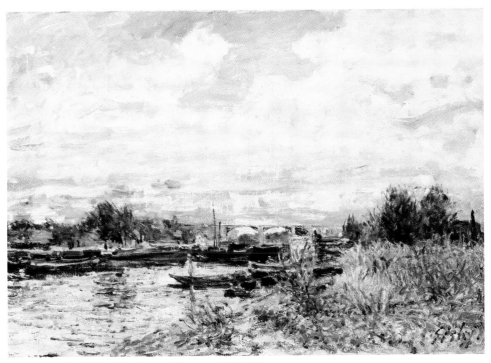

Plate 104. Alfred Sisley, *The Seine at Billancourt*, 1877-1878

Plate 17. Gustave Caillebotte, *The Seine at Argenteuil*, 1888

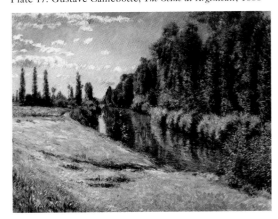

Plate 103. Alfred Sisley, *The Flood, Bank of the Seine in Autumn*, 1876

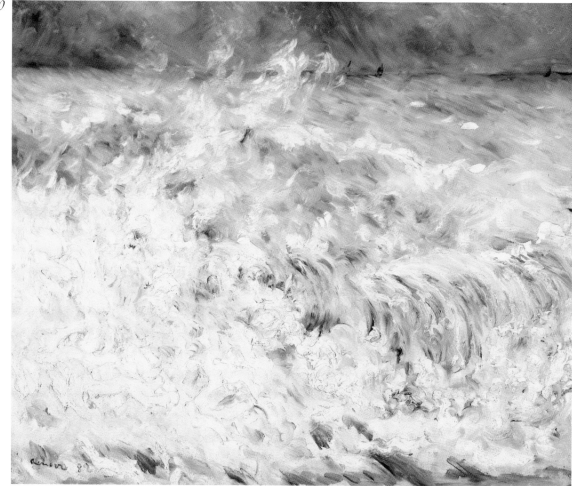

Plate 90. Pierre-Auguste Renoir, *The Wave*, 1882

Plate 92. Pierre-Auguste Renoir, *Study for the Large Bathers*, ca. 1886-1887

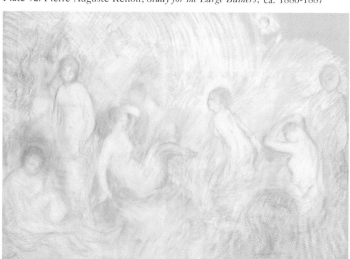

Plate 66. Claude Monet, *Port of Dieppe, Evening*, 1882

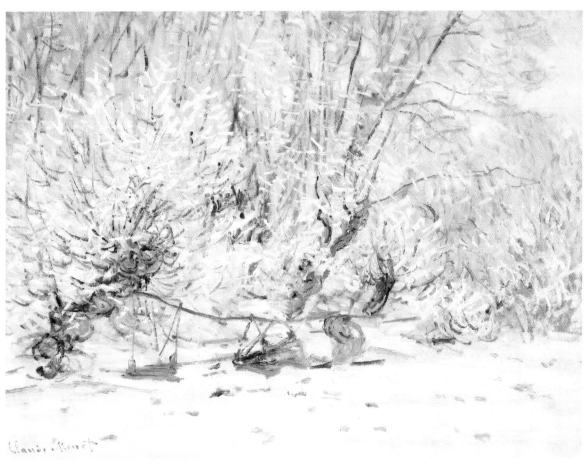

Plate 67. Claude Monet, *Hoar-Frost*, 1885

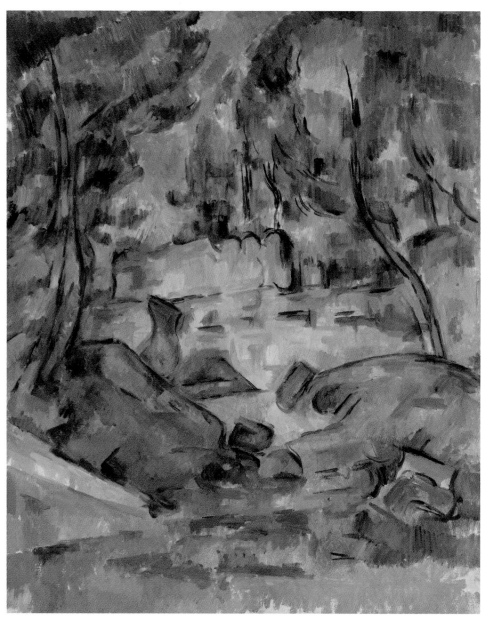

Plate 21. Paul Cézanne, *Trees and Rocks Near the Château Noir*, 1900-1906

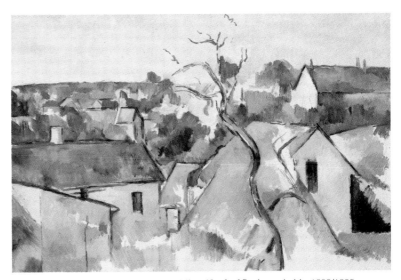

Plate 19. Paul Cézanne, *Rooftops in a Village North of Paris*, probably 1898/1899

Plate 20. Paul Cézanne, *Environs of Aix*, 1900-1906

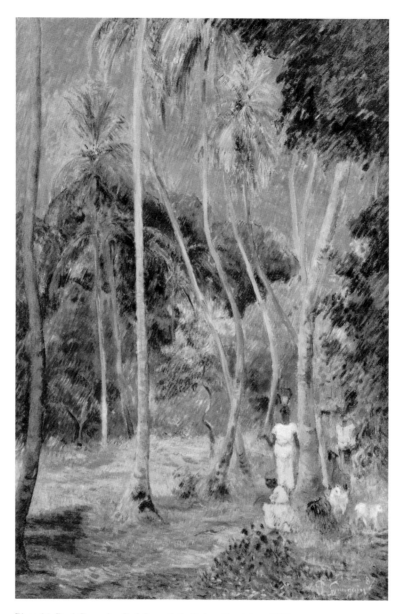

Plate 36. Paul Gauguin, *Path Beneath the Palms, Martinique*, 1887

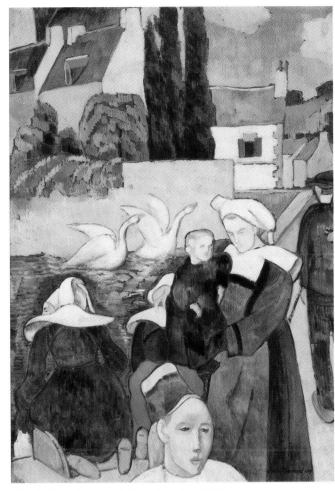

Plate 3. Emile Bernard, *Bridge at Pont Aven*, 1891

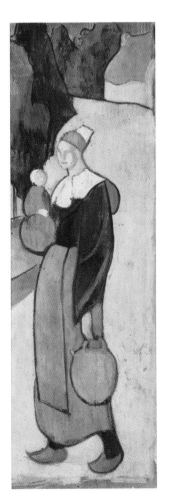

Plate 2. Emile Bernard, *Breton Woman*, 1888-1889

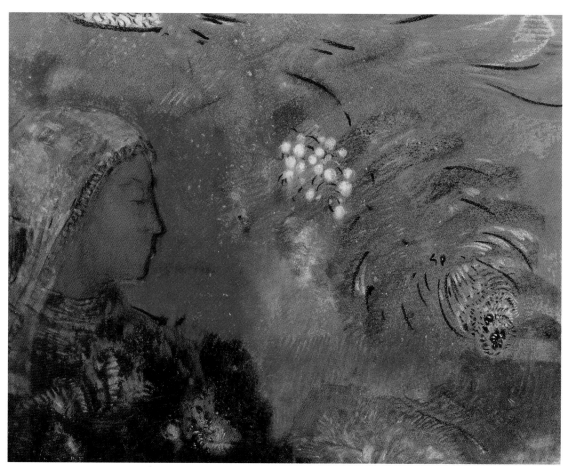

Plate 86. Odilon Redon, *Head of a Woman*

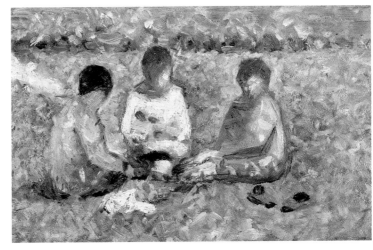

Plate 98. Georges Seurat, *The Picnic*, 1885

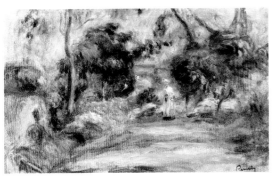

Plate 93. Pierre-Auguste Renoir, *Countryside at Cagnes*, 1917

Plate 30. Edgar Degas, *Before the Race*, 1885-1900

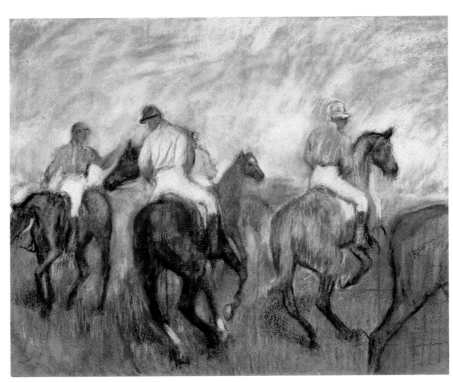

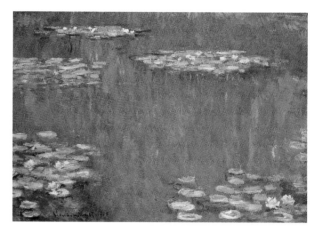

Plate 70. Claude Monet, *Water Lilies - Giverny*, 1905

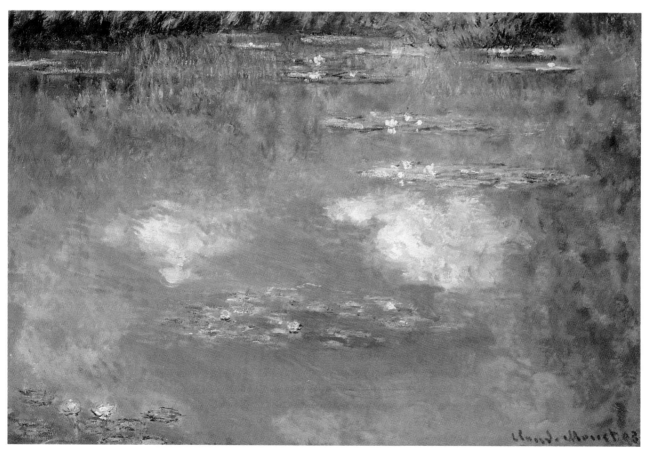

Plate 69. Claude Monet, *Water Lilies - The Cloud*, 1903

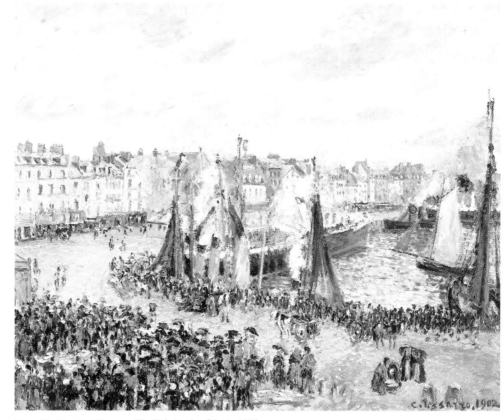

Plate 81. Camille Pissarro, *The Fish Market, Dieppe*, 1902

Plate 82. Camille Pissarro, *Outer Harbor of Le Havre*, 1903

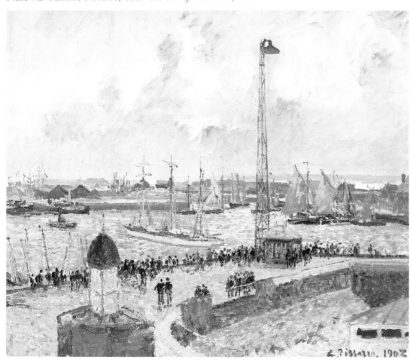

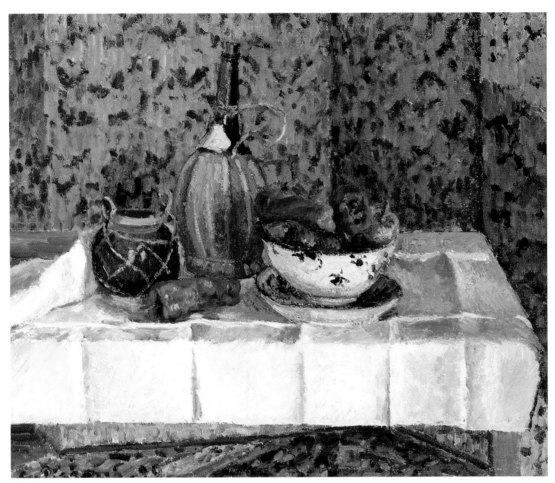

Plate 80. Camille Pissarro, *Still Life with Spanish Peppers*, 1899

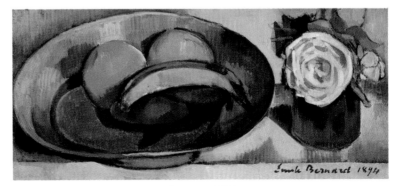

Plate 4. Emile Bernard, *Still Life with Banana*, 1894

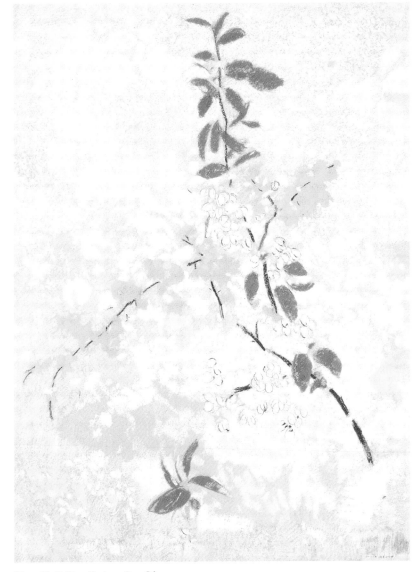

Plate 87. Odilon Redon, *Pear Blossoms*

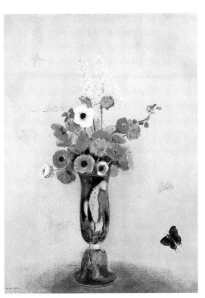

Plate 85. Odilon Redon,
Vase of Flowers with Butterflies, ca. 1915

Plate 84. Odilon Redon, *Flowers in a Vase*, 1903

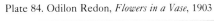

Plate 5. Pierre Bonnard, *Rue Tholozé*, ca. 1897

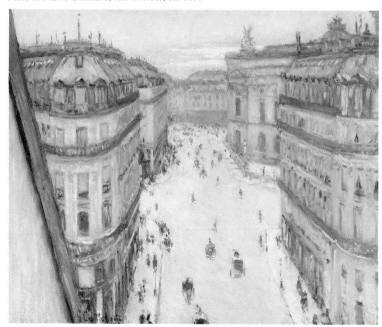

Plate 16. Gustave Caillebotte, *Rue Halevy, View from the Seventh Story*, 1878

Plate 115. Edouard Vuillard, *La Place Vintimille* (triptych), 1906-1908

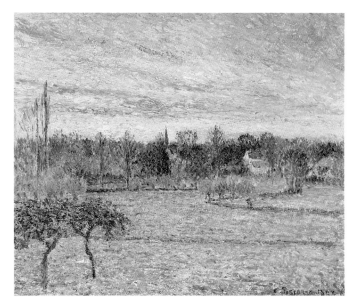

Plate 79. Camille Pissarro, *Red Sky at Bazincourt*, 1893

Plate 99. Paul Signac, *Mont St. Michel*, 1897

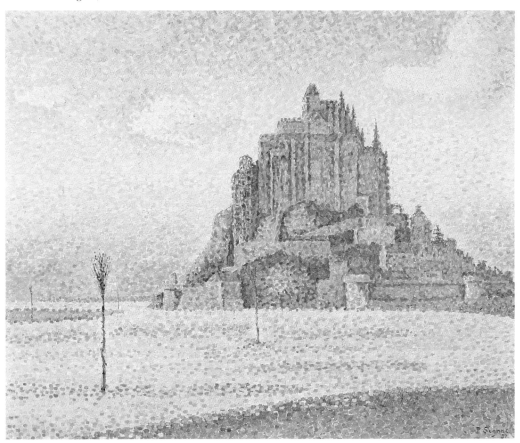

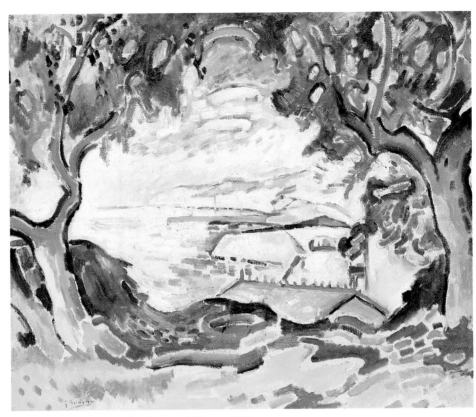

Plate 13. Georges Braque, *Landscape at L'Estaque*, 1906

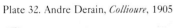

Plate 32. Andre Derain, *Collioure*, 1905

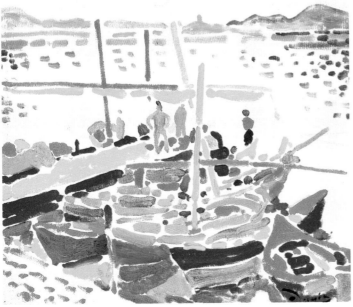

Plate 29. Edgar Degas, *Ballet Dancer with Red Bodice*, 1895-1900

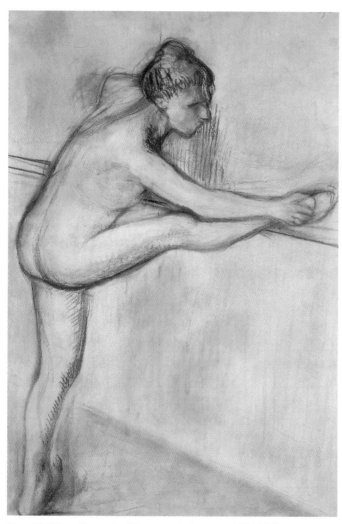

Plate 28. Edgar Degas, *Nude Dancer at the Barre*, ca. 1884-1888

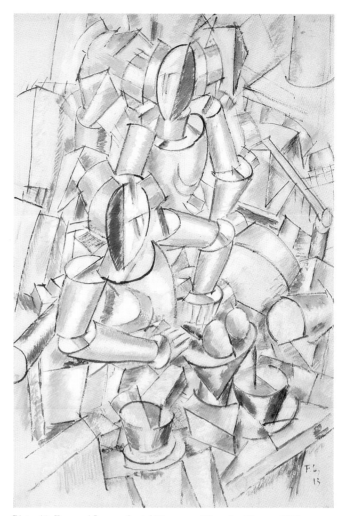

Plate 46. Fernand Leger, *Seated Woman and Standing Woman*, 1913

Plate 75. Pablo Picasso, *Nude with Folded Hands*, 1905

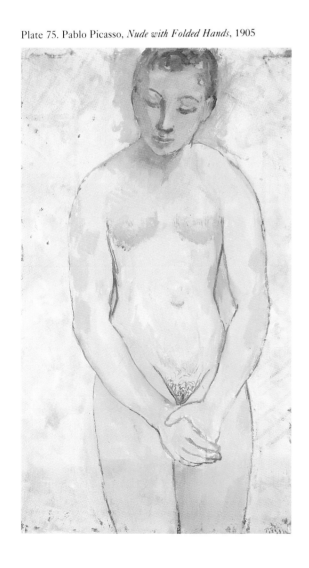

48

Plate 55. Joan Miro, *Queen Louise of Prussia*, 1929

Plate 38. Juan Gris, *Cubist Landscape*, 1917

Plate 37. Juan Gris, *Guitar and Pipe*, 1913

Plate 76. Pablo Picasso, *Still Life in a Landscape*, 1915

50

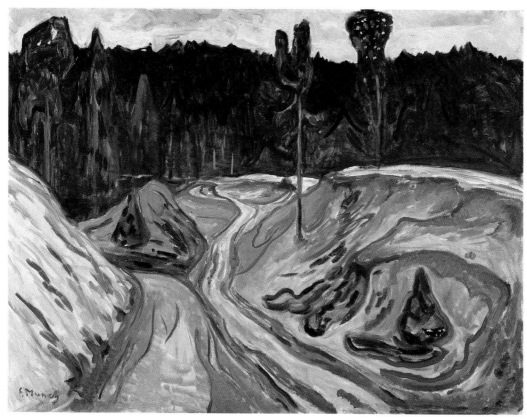

Plate 72. Edvard Munch, *Red Earth, Thuringian Forest*

Plate 111. Louis Valtat, *River Barges*, 1907

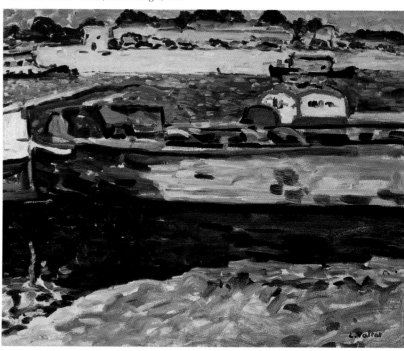

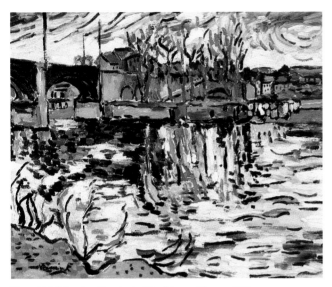

Plate 113. Maurice Vlaminck, *The Seine at Chatou*, 1906

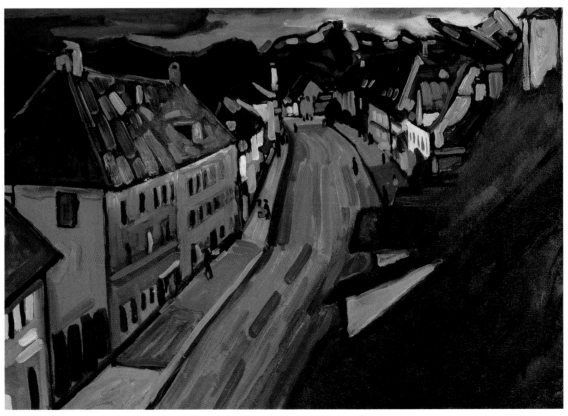

Plate 40. Wassily Kandinsky, *Street at Murnau with Mountains* (also known as *Murnau - Obermarkt*), 1908

52

Plate 73. Emil Nolde, *Poppies and Yellow Marguerites*

Plate 33. Raoul Dufy, *View through a Window, Nice*, ca. 1925

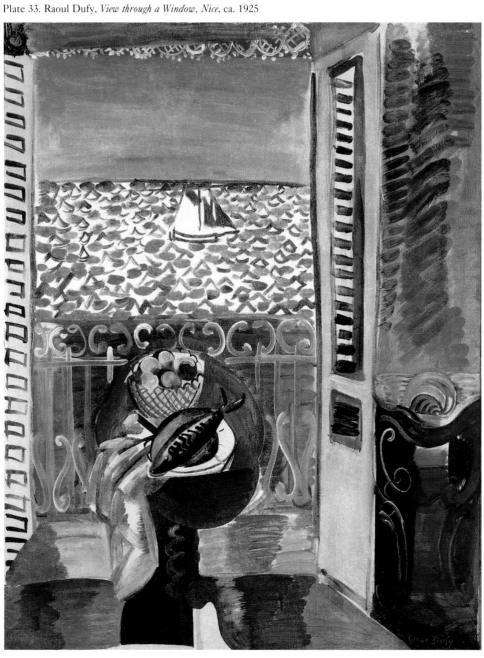

Plate 18. Charles Camoin, *Emilie Charmy at her Easel*, 1906

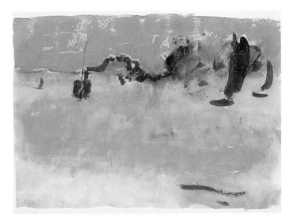

Plate 74. Emil Nolde, *Steamship and Sailing Boat*

Plate 42. Ernst Ludwig Kirchner, *Greenhouse and Garden*, 1917

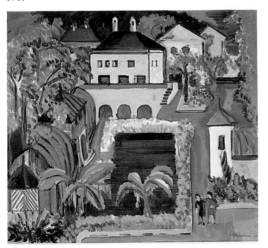

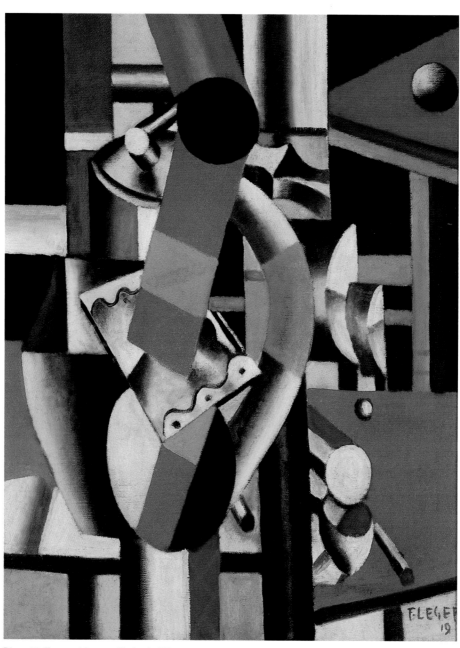

Plate 48. Fernand Leger, *Mechanical Forms*, 1919

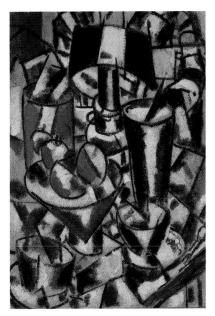

Plate 47. Fernand Leger,
Still Life with a Lamp, 1914

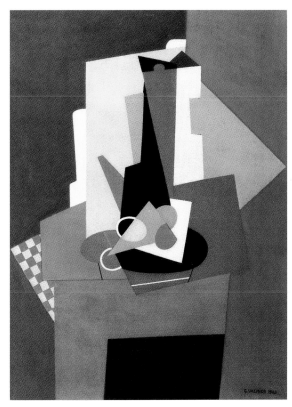

Plate 110. Georges Valmier, *Still Life #4*, 1922

Plate 54. Jean Metzinger, *Pipe and Parrot*, 1915

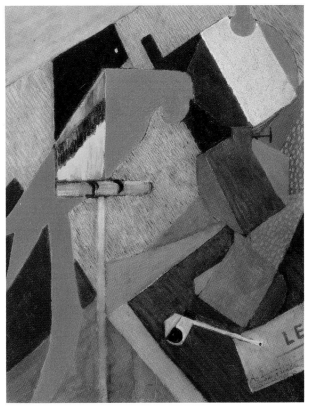

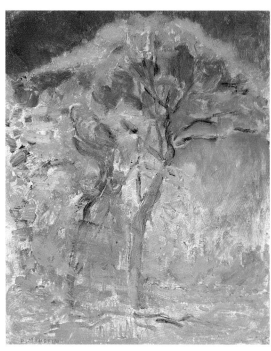

Plate 58. Piet Mondrian, *Trees Under Blue Sky*, ca. 1908

Plate 57. Piet Mondrian, *Chrysanthemum*,
ca. 1908

Plate 59. Piet Mondrian, *Dunes I*, ca. 1909

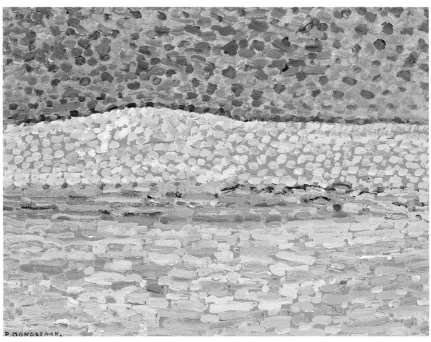

Plate 60. Piet Mondrian, *Facade of the Church at Domburg*, 1914

58

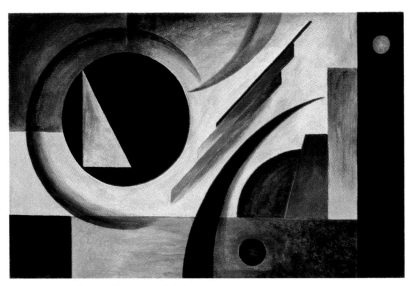

Plate 45. Anna Kogan, *Suprematist Painting*, 1921

Plate 83. Liubov Popova, *Spatial Force Construction*, 1924

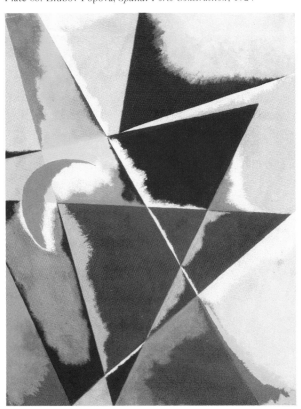

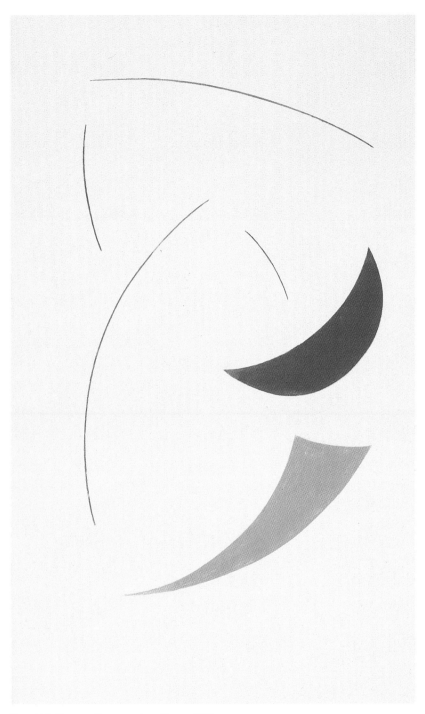

Plate 39. Vilmos Huszar, *Composition: Red, Yellow, Blue, Black, and Gray*, ca. 1919

Plate 112. Georges Vantongerloo, *Formes*, 1939

Plate 106. Nikolai Suetin, *Suprematism*, 1924

Plate 22. Ilia Chashnik, *Suprematist Color Lines in Horizontal Motion*, 1923

Plate 94. Alexandr Rodchenko, *Project for a Cover for the Magazine*, Lef, 1923

Plate 53. Mikhail Matiushin, *Star in White Ring*, 1922-1925

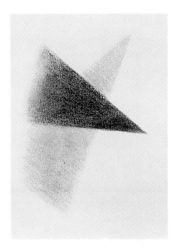

Plate 44. Ivan Kliun, *Suprematism*, 1920-1921

Plate 41. Wassily Kandinsky, *In Between*, 1932

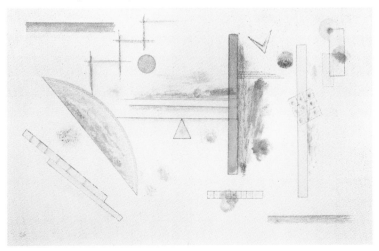

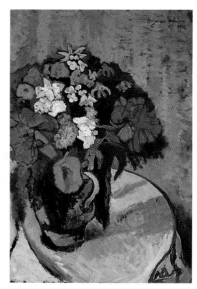

Plate 108. Suzanne Valadon,
Vase of Flowers, 1918

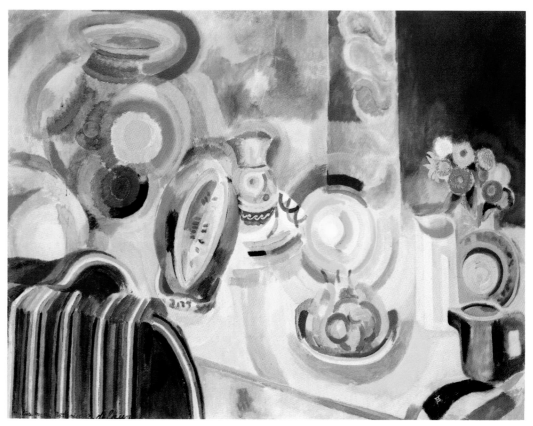

Plate 31. Robert Delaunay, *Portuguese Still Life*, 1916

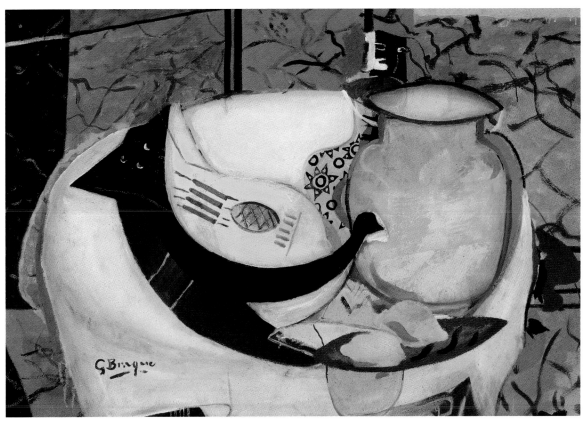

Plate 15. Georges Braque, *Still Life with Guitar*, 1936-1957

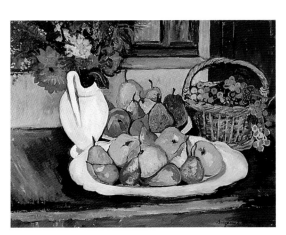

Plate 109. Suzanne Valadon, *Fruit and Flowers*, 1926

Plate 14. Georges Braque, *Still Life with Pot of Anemones*, 1925

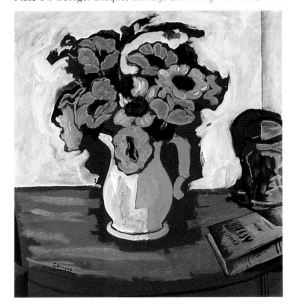

64

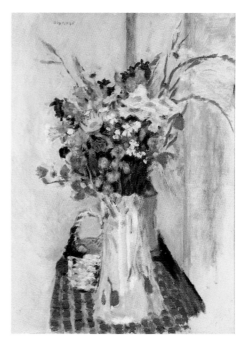

Plate 10. Pierre Bonnard,
Vase of Field Flowers, ca. 1932

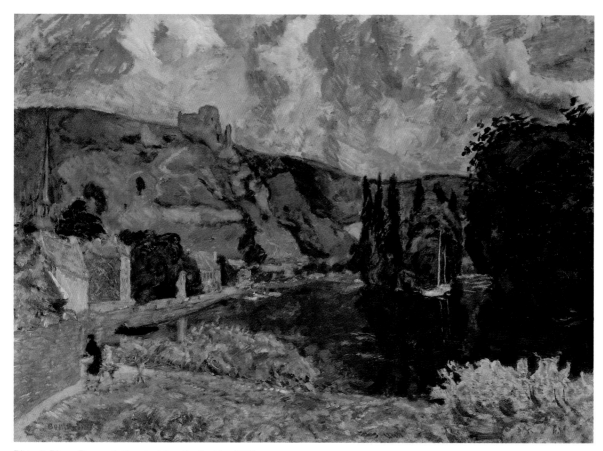

Plate 8. Pierre Bonnard, *Countryside at Les Andelys*, 1917

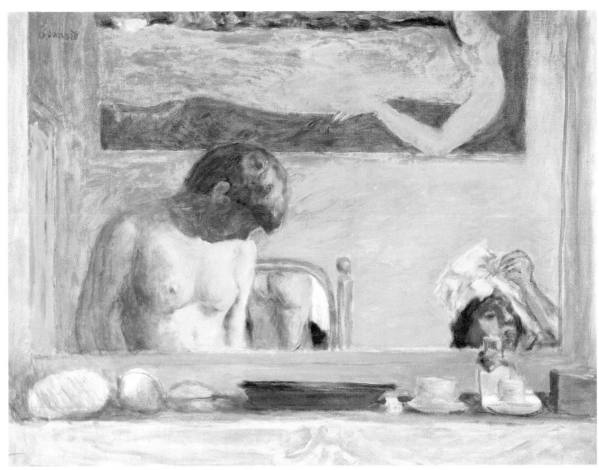

Plate 7. Pierre Bonnard, *Young Woman at her Toilette*, 1916

Plate 9. Pierre Bonnard,
*Woman at her Toilette ("The Dressing
Gown")*, ca. 1923

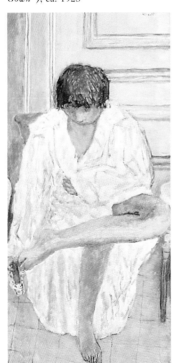

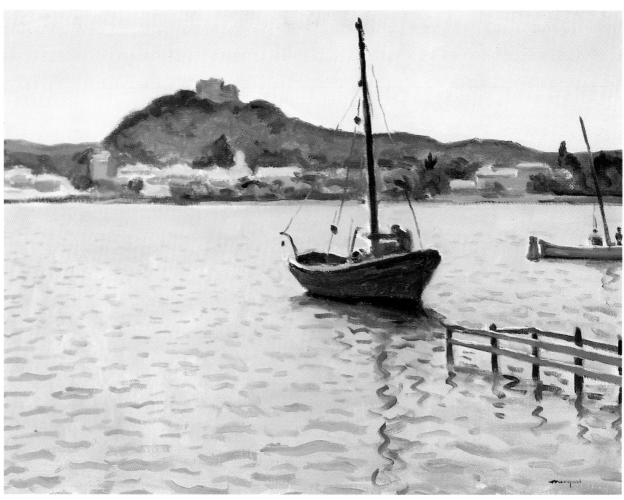

Plate 52. Albert Marquet, *Blue Boat at Porquerolles*, 1930's

67

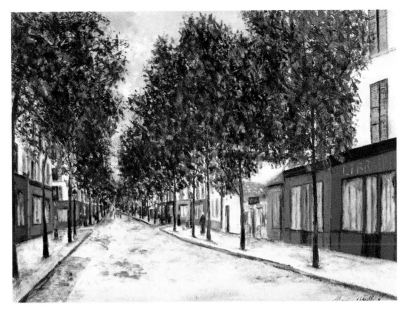

Plate 107. Maurice Utrillo, *The Road to Puteaux*, ca. 1915

Plate 116. Edouard Vuillard, *Landscape*, ca. 1920

Plate 114. Maurice Vlaminck, *The Village*, ca. 1910

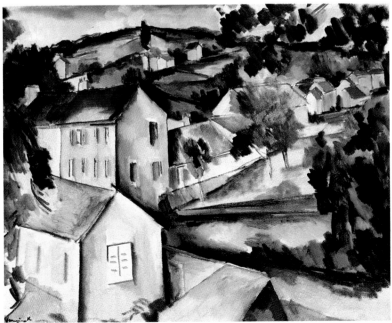

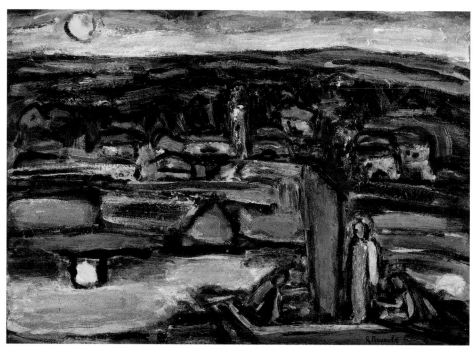

Plate 97. Georges Rouault, *Sermon on the Lake*, 1937-1938

Plate 95. Georges Rouault, *The Flagellation of Christ*, ca. 1912

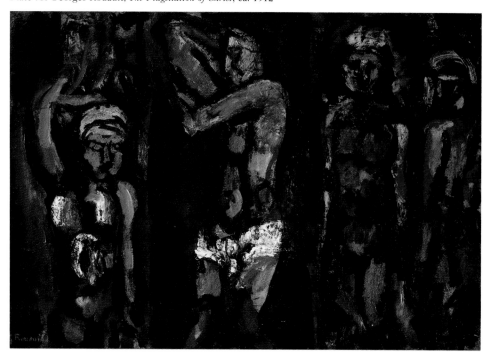

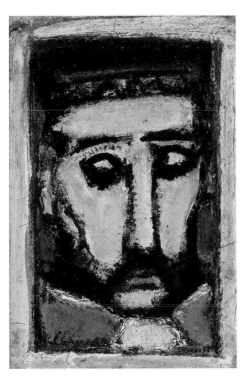

Plate 96. Georges Rouault, *The Judge*, 1937

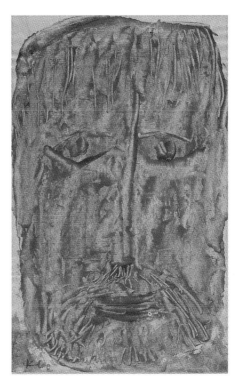

Plate 43. Paul Klee, *A Man in Pain*, 1933

Plate 49. Rene Magritte, *Our Daily Bread*, 1942

1. JULES BASTEIN-LEPAGE
(French, 1848-1884)
Sharpening the Scythe, 1881
Oil on canvas
31 3/4 x 40 inches
(80.7 x 101.5 cm.)
Signed and dated lower right: "J.
Bastien-Lepage/Damvillers
Meuse 1881"
Private collection, Dallas

2. EMILE BERNARD
(French, 1868-1941)
Breton Woman, 1888-1889
Oil on cardboard
32 7/8 x 11 inches (83.5 x 28 cm.)
Private collection, Dallas

3. EMILE BERNARD
(French, 1868-1941)
Bridge at Pont Aven, 1891
Oil on panel
45 1/2 x 32 1/2 inches
(115.6 x 82.5 cm.)
Signed and dated lower right:
"Emile Bernard 1891"
Dallas Museum of Fine Arts.
*Dallas Collects: Impressionist and
Early Modern Masters. An
Exhibition Celebrating the Seventy-
Fifth Anniversary of the Dallas
Museum of Fine Arts* (Dallas, 1978)
no. 55.
Private collection, Dallas

4. EMILE BERNARD
(French, 1868-1941)
Still Life with Banana, 1894
Oil on canvas
9 x 20 inches (22.8 x 50.8 cm.)
Signed and dated lower right:
"Emile Bernard 1894"
DMFA 1978, no. 57.
Private collection, Dallas

5. PIERRE BONNARD
(French, 1867-1947)
Rue Tholozé, ca. 1897
Unvarnished oil on cardboard
20 7/8 x 26 15/16 inches (53.5 x
68.5 cm.)
Signed lower left: "Bonnard"
Jean and Henry Dauberville.
*Bonnard; catalogue raisonné de
l'oeuvre peint*
(Paris, 1965-74) vol. I, no. 155.
Private collection

6. PIERRE BONNARD
(French, 1867-1947)
Environs of Vernon, 1915
Oil on canvas
32 x 27 inches (81.3 x 68.5 cm.)
Signed lower right: "Bonnard"
Dauberville, vol. II, no. 844.
Private collection

7. PIERRE BONNARD
(French, 1867-1947)
Young Woman at her Toilette, 1916
Oil on canvas
26 x 35 1/4 inches (66 x 91.2 cm.)
Studio stamp upper left:
"Bonnard"
Dauberville, vol. IV, no. 02109.
DMFA 1978, no. 49.
Private collection, Dallas

8. PIERRE BONNARD
(French, 1867-1947)
Countryside at Les Andelys, 1917
Oil on canvas
29 1/2 x 41 1/8 inches
(75 x 104 cm.)
Signed lower left: "Bonnard"
Dauberville, vol. II, no. 903.
Private collection, Dallas

9. PIERRE BONNARD
(French, 1867-1947)
*Woman at her Toilette ("The
Dressing Gown")*, ca. 1923
Oil on canvas
45 1/2 x 21 3/4 inches
(115 x 55 cm.)
Signed upper right: "Bonnard"
Dauberville, vol. III, no. 1218.
DMFA 1978, no. 50.
Private collection, Dallas

10. PIERRE BONNARD
(French, 1867-1947)
Vase of Field Flowers, ca. 1932
Oil on canvas
28 3/4 x 21 1/4 inches (73 x 54
cm.)
Signed upper left: "Bonnard"
Dauberville, vol. III, cat. no.
1494.
DMFA 1978, no. 51.
Private collection, Dallas

11. EUGENE BOUDIN
(French, 1824-1898)
*Honfleur: Fishing Boat Leaving the
Port*, ca. 1854-1857
Oil on panel
9 1/2 x 12 3/4 inches
(24 x 32.5 cm.)
Signed lower right: "E. Boudin"
Robert Schmit. *Eugène Boudin,
1824-1898*
(Paris, 1973) vol. I, no. 80.
DMFA 1978, no. 3.
Private collection, Dallas

12.. EUGENE BOUDIN
(French, 1824-1898)
*The Bay at the Mouth of the River
Elorn, Landerneau*, 1871
Oil on canvas
15 7/8 x 25 3/4 inches
(40.5 x 65.5 cm.)
Signed and dated lower left: "E.
Boudin 71"
Schmidt, vol. I, no. 560.
Private collection, Dallas

13. GEORGES BRAQUE
(French, 1882-1963)
Landscape at L'Estaque, 1906
Oil on canvas
23 5/8 x 28 3/4 inches
(60 x 70 cm.)
Signed lower left: "G. Braque"
DMFA 1978; no. 85.
Private collection, Dallas

14. GEORGES BRAQUE
(French, 1882-1963)
Still Life with Pot of Anemones,
1925
Oil on composition board
22 x 21 inches (56.5 x 53.4 cm.)
Signed and dated lower left: "G.
Braque/25"
Nicole S. Mangin.*Catalogue de
l'oeuvre de Georges Braque:
Peintures (1924-27)*
(Paris, 1968) no. 68.
Private collection

15. GEORGES BRAQUE
(French, 1882-1963)
Still Life with Guitar, 1936-1957
Oil and sand on canvas
31 3/4 x 41 3/4 inches (81 x 116
cm.)
Signed lower left: "G. Braque"
Nicole S. Mangin. *Catalogue de
l'oeuvre de Georges Braque,
Peintures (1948-1957)*
(Paris, 1959) no. 121.
DMFA 1978, no. 86.
Private collection, Dallas

16. GUSTAVE CAILLEBOTTE
(French, 1848-1894)
*Rue Halévy, View from the Seventh
Story*, 1878
Oil on canvas
23 1/2 x 29 1/8 inches (60 x 73
cm.)
Signed and dated lower left: "G.
Caillebotte/1878"
Marie Berhaut. *Caillebotte: sa vie
et son oeuvre: catalogue raisonné des
peintures et pastels*
(Paris, 1978) no. 116.
Private collection, Dallas

17. GUSTAVE CAILLEBOTTE
(French, 1848-1894)
The Seine at Argenteuil, 1888
Oil on canvas
29 1/2 x 39 1/2 inches
(75 x 100.3 cm.)
Signed and dated lower right:
"G. Caillebotte 1888"
Berhaut, no. 362.
Private collection, Dallas

18. CHARLES CAMOIN
(French, 1879-1965)
Emilie Charmy at her Easel, 1906
Oil on canvas
28 3/4 x 25 9/16 inches
(73 x 60 cm)
Signed lower right:
"Ch. Camoin"
Daniele Girandy. *Camoin: sa vie,
son oeuvre* (Lausanne, 1972)
catalogue no. 68.
DMFA 1978, no. 75.
Private collection, Dallas

19. PAUL CEZANNE
(French, 1839-1906)
Rooftops in a Village North of Paris,
probably 1898/1899
Oil on canvas
25 7/8 x 32 1/8 inches
(65.7 x 81.6 cm.)
John Rewald, revised edition (in
preparation) of Lionello Venturi,
Cézanne, son art - son oeuvre
(Paris, 1936).
DMFA 1978, no. 20.
Private collection, Dallas

20. PAUL CEZANNE
(French, 1839-1906)
Environs of Aix, 1900-1906
Watercolor and pencil on white
paper
14 3/8 x 21 1/4 inches
(36 x 54 cm.)
John Rewald. *Paul Cézanne. The
Watercolors. A Catalogue Raisonné*
(London,1983) no. 579.
Private collection, Dallas

21. PAUL CEZANNE
(French, 1839-1906)
*Trees and Rocks Near the Château
Noir*, 1900-1906
Oil on canvas
24 x 19 11/16 inches (61 x 50 cm.)
Venturi, no. 792.
Private collection

22. ILIA CHASHNIK
(Russian, 1902-1929)
*Suprematist Color Lines in
Horizontal Motion*, 1923
India ink and watercolor on
paper
4 5/16 x 14 1/8 inches
(11 x 36 cm.)
Signed with monogram in
Cyrillic and dated on reverse:
"23/Ch"
Private collection, Dallas

23. JOHN CONSTABLE
(English, 1776-1837)
Cloud Study at Hampstead Heath,
1820-1825?
Oil on paper
8 1/4 x 11 inches (20.9 x 27.9 cm.)
Private collection

**24. JEAN-BAPTISTE-CAMILLE
COROT**
(French, 1796-1875)
Semur, Path in the Woods,
1855-1860, retouched 1873
Oil on canvas
22 7/8 x 17 1/4 inches
(58.1 x 43.8 cm.)
Signed lower right: "Corot"
Alfred Robaut and Etienne
Moreau-Nélaton. *L'oeuvre de
Corot*
(Paris, 1905) vol. II, no. 841.
Lent by The Hockaday School
15.1980

**25. JEAN-BAPTISTE-CAMILLE
COROT**
(French, 1796-1875)
Environs of Sevres, ca. 1870
Oil on canvas
12 3/5 x 18 inches
(31.4 x 45.7 cm.)
Signed lower right: "Corot"
Robaut and Moreau-Nélaton,
vol. III, no. 1544.
Private collection, Dallas

26. HONORE DAUMIER
(French, 1808-1879)
Children Dancing, 1850-1853
Oil on canvas mounted on panel
10 1/2 x 8 1/2 inches (27 x 21 cm.)
K.E. Maison. *Honoré Daumier:
Catalogue Raisonné of the Paintings,
Watercolors, and Drawings*
(New York, 1968) vol. I, no. 79.
Private collection

27. EDGAR DEGAS
(French, 1834-1917)
Ballet Dancer with a Fan, ca. 1879
Pastel on paper
17 3/4 x 11 3/8 inches
(45 x 29 cm.)
Signed upper left: "Degas"
Paul A. Lemoisne. *Degas et son
oeuvre* (Paris, 1946) vol. II, no.
545.
DMFA 1978, no. 11.
Private collection, Dallas

28. EDGAR DEGAS
(French, 1834-1917)
Nude Dancer at the Barre,
ca. 1884-1888
Charcoal and pastel on paper
40 x 28 1/2 inches
(109.3 x 72.5 cm.)
Signed upper right: "Degas"
Lemoisne, vol. III, no. 812.
Private collection, Dallas

29. EDGAR DEGAS
(French, 1834-1917)
Ballet Dancer with Red Bodice,
1895-1900
Pastel and charcoal on tracing
paper, mounted on heavy paper
15 x 8 inches (38.1 x 20.3 cm.)
Estate stamp on tracing paper
lower left, and on heavy paper
lower right: "Degas"
Lemoisne, vol. III, no. 1349.
Private collection

30. EDGAR DEGAS
(French, 1834-1917)
Before the Race, 1885-1900
Pastel and graphite on paper
29 15/16 x 37 13/16 inches
(76 x 96 cm.)
Estate stamp lower left: "Degas"
Lemoisne, vol. III, no. 939.
Private collection, Dallas

31. ROBERT DELAUNAY
(French, 1885-1941)
Portuguese Still Life, 1916
Oil on canvas
41 1/4 x 53 3/4 inches
(104.7 x 136.6 cm.)
Inscribed and signed lower left:
"nature morte Portugaise r.
delaunay"
Guy Habasque. "Catalogue de
l'oeuvre de Robert Delaunay,"
Du Cubisme a l'art abstrait (Paris,
1957) no. 184.
DMFA 1978, no. 90.
Private collection, Dallas

32. ANDRE DERAIN
(French, 1880-1954)
Collioure, 1905
Oil on canvas
14 15/16 x 18 3/8 inches
(38 x 46 cm.)
Signed lower right: "Derain"
DMFA 1978, no. 77.
Private collection, Dallas

33. RAOUL DUFY
(French, 1877-1953)
View through a Window, Nice,
ca. 1925
Oil on canvas
36 x 28 inches (91.5 x 71 cm.)
Signed lower right: "Raoul
Dufy"
Private collection

34. HENRI FANTIN-LATOUR
(French, 1836-1904)
A Corner of the Studio, 1861
Oil on canvas
9 5/8 x 16 1/4 inches
(24.5 x 42 cm.)
Signed and dated upper left:
"Fantin 61"
Madame Fantin-Latour.
*Catalogue de l'oeuvre complet de
Fantin Latour*
(Paris, 1911) no. 181.
Collection of Marcia and Alan M.
May, Dallas

35. HENRI FANTIN-LATOUR
(French, 1836-1904)
Still Life with Narcissus, 1881
Oil on canvas
14 1/2 x 11 inches (37 x 28 cm.)
Signed and dated upper left:
"Fantin 81"
Madame Fantin Latour, no.
1026.
Private collection, Dallas

36. PAUL GAUGUIN
(French, 1848-1903)
Path Beneath the Palms, Martinique,
1887
Oil on canvas
35 1/8 x 23 3/4 inches
(89.2 x 60.4 cm.)
Signed and dated lower right:
"P. Gauguin 87"
Georges Wildenstein. *Paul
Gauguin* (Paris, 1964) vol. I, no.
228.
Private collection, Dallas

37. JUAN GRIS
(Spanish, 1887-1927)
Guitar and Pipe, 1913
Oil and charcoal on canvas
25 1/2 x 19 3/4 inches (65 x 50
cm.)
Signed upper left: "Juan Gris"
DMFA 1978, no. 94.
Private collection, Dallas

38. JUAN GRIS
(Spanish, 1887-1927)
Cubist Landscape, 1917
Oil on panel
45 1/2 x 28 1/2 inches
(115.6 x 72.4 cm.)
Signed lower left: "Juan Gris"
Douglas Cooper. *Juan Gris: Catalogue raisonné de l'oeuvre peint établi avec la collaboration de Margaret Potter*
(Paris, 1977) vol. I, no. 227.
DMFA 1978, no. 95.
Algur H. Meadows Collection, Meadows Museum, Southern Methodist University, Dallas

39. VILMOS HUSZAR
(Hungarian, 1884-1960)
Composition: Red, Yellow, Blue, Black, and Gray, ca. 1919
Oil on board
18 x 16 inches (45.7 x 40.6 cm.)
[with integral frame]
Signed lower right: "V. Huszar"
Private collection, Dallas

40. WASSILY KANDINSKY
(Russian, 1866-1944)
Street at Murnau with Mountains (also known as Murnau - Obermarkt), 1908
Oil on cardboard
19 3/4 x 27 1/4 inches
(50 x 69 cm.)
Hans K. Roethel and Jean K. Benjamin. *Kandinsky: Catalogue Raisonné of the Oil Paintings* (Ithaca, New York, 1982) vol. I, no. 211.
DMFA 1978, no. 92.
Private collection, Dallas

41. WASSILY KANDINSKY
(Russian, 1866-1944)
In Between, 1932
Watercolor and gouache
12 x 18 3/4 inches
(30.4 x 47.6 cm.)
Signed with monogram and dated lower left: "K 32"
Kandinsky's house catalogue no. 468
Private collection, Dallas

42. ERNST LUDWIG KIRCHNER
(German, 1880-1938)
Greenhouse and Garden, 1917
Oil on canvas
31 1/2 x 35 1/4 inches
(80 x 89.5 cm.)
Signed and dated lower right: "E.L. Kirchner 17"
Donald E. Gordon. *Ernst Ludwig Kirchner*
(Cambridge, 1968) no. 510.
DMFA 1978, no. 78.
Private collection, Dallas

43. PAUL KLEE
(Swiss, 1879-1940)
A Man in Pain, 1933
Colored paste (Kleisterfarbe) on paper, mounted by the artist on board
12 3/4 x 8 1/4 inches
(32.5 x 20.7 cm.)
Signed on paper, lower left: "Klee"
Inscribed on the mount: "1933, F5 Ein Mann der Schmerzen"
Klee's house catalogue no. 405 (F5)
Private collection, Dallas

44. IVAN KLIUN
(Russian, 1873-1942)
Suprematism, 1920-1921
Pastel on paper
8 3/4 x 6 5/16 inches
(22.3 x 16.1 cm.)
Signed in Cyrillic on reverse: "I. Kliun"
Private collection, Dallas

45. ANNA KOGAN
(Russian, 1902-1974)
Suprematist Painting, 1921
Oil on canvas
19 x 29 5/16 inches
(48.2 x 74.5 cm.)
Signed in Cyrillic on reverse: "Kogan"
Private collection, Dallas

46. FERNAND LEGER
(French, 1881-1955)
Seated Woman and Standing Woman, 1913
Ink, watercolor, and gouache on paper
20 7/8 x 14 1/8 inches
(53 x 35.8 cm.)
Signed and dated lower right: "FL 13"
Private collection, Dallas

47. FERNAND LEGER
(French, 1881-1955)
Still Life with a Lamp, 1914
Oil on canvas
25 1/2 x 18 inches
(64.8 x 45.7 cm.)
DMFA 1978, no. 82.
Lent by The James H. Clark Family
2.1985

48. FERNAND LEGER
(French, 1881-1955)
Mechanical Forms, 1919
Oil on canvas
25 1/2 x 19 1/2 inches
(64.8 x 49.5 cm.)
Signed and dated lower right: "F. Leger/19"
Lent by The James H. Clark Family
3.1985

49. RENE MAGRITTE
(Belgian, 1898-1967)
Our Daily Bread, 1942
Oil on canvas
35 3/4 x 27 1/8 inches
(90.7 x 68.9 cm.)
Signed lower left: "Magritte"
Private collection, Dallas

50. EDOUARD MANET
(French, 1832-1883)
Profile of a Young Woman, ca. 1880
Oil on canvas
12 x 9 7/8 inches (33 x 25 cm.)
Denis Rouart and Daniel Wildenstein. *Edouard Manet, catalogue raisonné* (Lausanne/Paris, 1975) vol. I, no. 339.
Private collection (RSAC), Dallas

51. EDOUARD MANET
(French, 1832-1883)
The Bugler, 1882
Oil on canvas
39 x 31 5/8 inches (99 x 80.3 cm.)
Rouart and Wildenstein, vol. I, no. 392.
Private collection, Dallas

52. ALBERT MARQUET
(French, 1875-1947)
Blue Boat at Porquerolles, 1930's
Oil on canvas
17 1/2 x 23 1/4 inches
(44.5 x 59 cm.)
Signed lower right: "Marquet"
Private collection

53. MIKHAIL MATIUSHIN
(Russian, 1861-1934)
Star in White Ring, 1922-1925
Ink, pencil, crayon, and watercolor on paper
8 3/4 x 8 3/4 inches
(22.2 x 22.2 cm.)
Private collection, Dallas

54. JEAN METZINGER
(French, 1883-1956)
Pipe and Parrot, 1915
Oil on composition board
24 x 18 3/8 inches (61 x 46.5 cm.)
Signed lower left: "Metzinger"
Private collection, Dallas

55. JOAN MIRO
(Spanish, 1893-1974)
Queen Louise of Prussia, 1929
Oil on canvas
32 1/2 x 39 3/4 inches
(82.4 x 101 cm.)
Jacques Dupin. *Miró, Life and Work*. (New York, 1962) no. 241.
DMFA 1978, no. 97.
Algur H. Meadows Collection, Meadows Museum, Southern Methodist University, Dallas

56. PIET MONDRIAN
(Dutch, 1872-1944)
Windmill at Blaricum, 1908
Oil on canvas
39 3/8 x 37 1/4 inches
(99.5 x 94.6 cm.)
Signed lower right: "Piet Mondriaan"
Robert P. Welsh. *Piet Mondrian's Early Career, The Naturalistic Periods*
(New York, 1977) no. 219.
DMFA 1978, no. 67.
Private collection, Dallas

57. PIET MONDRIAN
(Dutch, 1872-1944)
Chrysanthemum, ca. 1908
Oil on canvas
19 3/4 x 13 3/4 inches
(50.2 x 34.9 cm.)
Michel Seuphor. *Piet Mondrian: Life and Work* (New York, 1956) no. 130.
DMFA 1978, no. 66.
Private collection, Dallas

58. PIET MONDRIAN
(Dutch, 1872-1944)
Trees Under Blue Sky, ca. 1908
Oil on canvas
17 1/4 x 14 1/4 inches
(44 x 36.3 cm.)
Signed lower left:
"P. Mondriaan"
Private collection, Dallas

59. PIET MONDRIAN
(Dutch, 1872-1944)
Dunes I, ca. 1909
Oil on composition board
11 x 15 inches (28 x 38 cm.)
Signed lower left:
"P. Mondriaan"
DMFA 1978, no. 69.
Private collection, Dallas

60. PIET MONDRIAN
(Dutch, 1872-1944)
Facade of the Church at Domburg,
1914
Charcoal and ink on paper
24 1/2 x 14 3/4 inches
(62.2 x 37.4 cm.)
Signed and dated lower center:
"PM14"
Seuphor, no. 252.
DMFA 1978, no. 76.
Private collection, Dallas

60a. PIET MONDRIAN
(Dutch, 1872-1944)
Composition No. 7 (Facade), 1914
Oil on canvas
47 1/2 x 39 7/8 inches
(120.6 x 101.3 cm.)
Signed and dated lower left:
"Mondrian 1914"
Seuphor, no. 271.
The Kimbell Museum, Fort
Worth, Gift of the Anne Burnett
and Charles Tandy Foundation
of Fort Worth in memory of
Anne Burnett Tandy, 1983

61. PIET MONDRIAN
(Dutch, 1872-1944)
Composition with Black Lines, 1934
Oil on canvas
23 3/8 x 23 3/4 inches
(59.4 x 60.3 cm.)
Signed and dated lower center:
"PM 34"
Seuphor, no. 532.
DMFA 1978, no. 72.
Anonymous loan
4.1967

62. CLAUDE MONET
(French, 1840-1926)
Village Street, 1869-1871
Oil on canvas
17 1/8 x 25 3/4 inches
(43.5 x 65.5 cm.)
Estate stamp lower right:
"Claude Monet"
Daniel Wildenstein. *Claude
Monet, biographie et catalogue
raisonné*
(Lausanne/Paris, 1974-1979) vol.
I, no. 243.
Private collection

63. CLAUDE MONET
(French, 1840-1926)
The Fête d'Argenteuil, 1872
Oil on canvas
23 1/2 x 31 5/8 inches
(60.5 x 80.5 cm.)
Signed lower right: "Claude
Monet"
Wildenstein, vol. II, no. 241.
Private collection, Dallas

64. CLAUDE MONET
(French, 1840-1926)
The Tea Set, 1872
Oil on canvas
20 7/8 x 28 9/16 inches
(53 x 72.5 cm.)
Signed lower left: "Claude
Monet"
Wildenstein, vol. I, no. 244.
Private collection, Dallas

65. CLAUDE MONET
(French, 1840-1926)
The Boat Basin at Argenteuil, 1874
Oil on canvas
21 5/8 x 28 3/8 inches
(55 x 73 cm.)
Signed lower left: "Claude
Monet"
Wildenstein, vol. I, no. 326.
Private collection, Dallas

66. CLAUDE MONET
(French, 1840-1926)
Port of Dieppe, Evening, 1882
Oil on canvas
27 3/16 x 28 3/4 inches
(69 x 73 cm.)
Estate stamp lower right:
"Claude Monet"
Wildenstein, vol. II, no. 706
Private collection

67. CLAUDE MONET
(French, 1840-1926)
Hoar-Frost, 1885
Oil on canvas
23 3/4 x 31 5/8 inches
(60.5 x 80.5 cm.)
Signed lower left: "Claude
Monet"
Wildenstein, vol. II, no. 964.
Private collection, Dallas

68. CLAUDE MONET
(French, 1840-1926)
Poplars, Pink Effect, 1891
Oil on canvas
37 x 29 1/4 inches (94 x 74.3 cm.)
Signed and dated lower left:
"Claude Monet 91"
Wildenstein, vol. III, no. 1304.
DMFA 1978, no. 25.
Private collection, Dallas

69. CLAUDE MONET
(French, 1840-1926)
Water Lilies - The Cloud, 1903
Oil on canvas
29 3/8 x 42 1/2 inches
(74.6 x 105.3 cm.)
Signed and dated lower right:
"Claude Monet 03"
Wildenstein, vol IV, no. 1656.
Private collection, Dallas

70. CLAUDE MONET
(French, 1840-1926)
Water Lilies - Giverny, 1905
Oil on canvas
28 3/4 x 42 inches (73 x 105 cm.)
Signed and dated lower left:
"Claude Monet 1905"
Wildenstein, vol. IV, no. 1678
DMFA 1978, no. 27.
Private collection, Dallas

71. BERTHE MORISOT
(French, 1841-1895)
The Haystack, 1883
Oil on canvas
21 3/4 x 18 inches
(55.3 x 45.7 cm.)
Estate stamp lower left: "Berthe
Morisot"
Private collection, Dallas

72. EDVARD MUNCH
(Norwegian, 1863-1944)
Red Earth, Thuringian Forest
Oil on canvas
30 x 39 3/8 inches
(76.2 x 109 cm.)
Signed lower left: "E. Munch";
signed again on reverse: "E.
Munch" and "Munch"
Private collection, Dallas

73. EMIL NOLDE
(German, 1867-1956)
Poppies and Yellow Marguerites
Watercolor on paper
9 7/8 x 18 7/8 inches
(25.1 x 48 cm.)
Signed lower right: "Nolde"
Private collection, Dallas

74. EMIL NOLDE
(German, 1867-1956)
Steamship and Sailing Boat
Watercolor on paper
9 1/2 x 13 1/4 inches
(24 x 33.8 cm.)
Signed lower left: "Nolde"
Private collection

75. PABLO PICASSO
(Spanish, 1881-1973)
Nude with Folded Hands, 1905
Gouache on paper
22 3/4 x 14 3/4 inches
(57.8 x 37.4 cm.)
Signed lower right: "Picasso"
Christian Zervos. *Pablo Picasso*
(Paris, 1932-1978) vol. I, no. 258.
DMFA 1978, no. 79.
Private collection, Dallas

76. PABLO PICASSO
(Spanish, 1881-1973)
Still Life in a Landscape, 1915
Oil on canvas
24 1/2 x 29 3/4 inches
(62.3 x 75.5 cm.)
Signed upper left: "Picasso"
(signed in 1952)
Zervos, vol. I, no. 541.
DMFA 1978, no. 80.
Algur H. Meadows Collection,
Meadows Museum, Southern
Methodist University, Dallas

77. CAMILLE PISSARRO
(French, 1830-1903)
View of Pontoise, 1873
Oil on canvas
20 3/4 x 32 3/16 inches
(52.7 x 81.7 cm.)
Signed and dated lower left: "C.
Pissarro 1873"
Ludovic R. Pissarro and Lionello
Venturi. *Camille Pissarro; son art,
son oeuvre* (Paris, 1939) no. 210.
Private collection, Dallas

78. CAMILLE PISSARRO
(French, 1830-1903)
The Sower - Montfoucault, 1875
Oil on canvas
18 1/8 x 21 5/8 inches
(46 x 55 cm.)
Signed and dated at lower right:
"Pissarro 1875"
Pissarro and Venturi, no. 331.
Private collection, Dallas

79. CAMILLE PISSARRO
(French, 1830-1903)
Red Sky at Bazincourt, 1893
Oil on canvas
18 1/8 x 21 3/4 inches
(46 x 55.3 cm.)
Signed and dated lower right:
"C. Pissarro 1893"
Pissarro and Venturi, no. 840.
Private collection, Dallas

80. CAMILLE PISSARRO
(French, 1830-1903)
Still Life with Spanish Peppers,
1899
Oil on canvas
21 1/2 x 25 3/4 inches
(54.6 x 65.4 cm.)
Signed and dated lower left:
"C. Pissarro 99"
Pissarro and Venturi, no. 1069.
Private collection, Dallas

81. CAMILLE PISSARRO
(French, 1830-1903)
The Fish Market, Dieppe, 1902
Oil on canvas
25 3/4 x 32 inches (65.4 x 81 cm.)
Signed and dated lower right:
"C. Pissarro 1902" Inscribed on
reverse: "Le Matin temps
gris...La poissonnerie à Dieppe"
Pissarro and Venturi, vol. I, no.
1250.
DMFA 1978, no. 9.
Private collection, Dallas

82. CAMILLE PISSARRO
(French, 1830-1903)
Outer Harbor of Le Havre, 1903
Oil on canvas
18 1/8 x 21 5/8 inches
(46 x 55 cm.)
Signed and dated lower right: "C.
Pissarro 1903"
Pissarro and Venturi, no. 1312.
Private collection, Dallas

83. LIUBOV POPOVA
(Russian, 1889-1924)
Spatial Force Construction,
ca. 1920
Gouache on paper
22 x 17 inches (55.9 x 43.1 cm.)
Private collection, Dallas

84. ODILON REDON
(French, 1840-1916)
Flowers in a Vase, 1903
Pastel on paper
21 x 17 1/2 inches
(53.4 x 44.5 cm.)
Signed lower right: "Odilon
Redon"
Private collection, Dallas

85. ODILON REDON
(French, 1840-1916)
Vase of Flowers with Butterflies,
ca. 1915
Oil on canvas
28 3/4 x 21 1/4 inches
(73 x 54 cm.)
Signed lower left: "Odilon
Redon"
Klaus Berger. *Odilon Redon,
Phantasie und Farbe*
(Cologne, 1964) no. 305.
DMFA 1978, no. 31.
Private collection, Dallas

86. ODILON REDON
(French, 1840-1916)
Head of a Woman
Pastel on brown paper
16 1/4 x 21 inches
(41.3 x 53.3 cm.)
Signed lower right: "Odilon
Redon"
*International Exhibition of Modern
Art*, Armory of the 69th Infantry,
New York, Feb. 15-March 15,
1913, no. 304.
DMFA 1978, no. 29.
Dallas Museum of Art, life
interest gift from Mrs. Beatrice
Haggerty
1981.197

87. ODILON REDON
(French, 1840-1916)
Pear Blossoms
Pastel on paper
28 x 21 inches (71.2 x 53.3 cm.)
Signed lower right: "Odilon
Redon"
Private collection

88. PIERRE-AUGUSTE RENOIR
(French, 1841-1919)
The Duck Pond, 1873
Oil on canvas
18 5/8 x 22 1/8 inches
(47.4 x 56.2 cm.)
Signed lower left: "Renoir"
Barbara Ehrlich White. *Renoir, his
Life, Art, and Letters*
(New York, 1984) p. 47.
Private collection, Dallas

89. PIERRE-AUGUSTE RENOIR
(French, 1841-1919)
Roses in a Vase, 1876
Oil on canvas
23 7/8 x 20 1/4 inches
(60.6 x 51.4 cm.)
Signed lower left: "Renoir"
DMFA 1978, no. 34.
Private collection, Dallas

90. PIERRE-AUGUSTE RENOIR
(French, 1841-1919)
The Wave, 1882
Oil on canvas
21 x 25 inches (53.3 x 63.5 cm.)
Signed and dated lower left:
"Renoir 82"
Private collection

91. PIERRE-AUGUSTE RENOIR
(French, 1841-1919)
Woman Combing Her Hair,
ca. 1882-1883
Oil on canvas
21 1/4 x 25 1/2 inches
(54 x 64.7 cm.)
Signed lower right: "Renoir"
Francois Daulte. *Auguste Renoir,
catalogue raisonné de l'oeuvre peint*
(Lausanne, 1971) vol. I, no. 502.
DMFA 1978, no. 37.
Private collection, Dallas

92. PIERRE-AUGUSTE RENOIR
(French, 1841-1919)
Study for the Large Bathers,
ca. 1886-1887
Red and white chalk on paper
27 x 39 inches (68.6 x 99 cm.)
Signed with monogram lower
left: "R"
Private collection, Dallas

93. PIERRE-AUGUSTE RENOIR
(French, 1841-1919)
Countryside at Cagnes, 1917
Oil on canvas
11 1/2 x 17 3/4 inches
(29 x 45 cm.)
Signed lower right: "Renoir"
Private collection, Dallas

94. ALEXENDR RODCHENKO
(Russian, 1891-1956)
*Project for a Cover for the
Magazine*, Lef, 1923
Gouache on paper
11 7/8 x 7 1/2 inches (30 x 19 cm.)
Signed in Cyrillic and dated on
reverse: "N.2 Rodchenko.23"
Private collection, Dallas

95. GEORGES ROUAULT
(French, 1871-1958)
The Flagellation of Christ, ca. 1912
Oil on canvas
25 1/4 x 35 3/4 inches
(64 x 90.8 cm.)
Signed lower left: "G. Rouault"
DMFA 1978, no. 59.
Dallas Museum of Art, life
interest gift from Mrs. Beatrice
Haggerty
1981.198

96. GEORGES ROUAULT
(French, 1871-1958)
The Judge, 1937
Oil on panel
17 1/8 x 12 inches
(43.5 x 30.4 cm.)
Signed lower right: "G. Rouault"
Bernard Dorival and Isabelle
Rouault. *Rouault, l'oeuvre peint*
(Monte Carlo, 1988) vol. II, no.
1804.
Private collection, Dallas

97. GEORGES ROUAULT
(French, 1871-1958)
Sermon on the Lake, 1937-1938
Oil on panel
17 1/2 x 25 inches
(44.5 x 63.5 cm.)
Signed lower right: "G. Rouault"
Private collection

98. GEORGES SEURAT
(French, 1859-1891)
The Picnic, 1885
Oil on panel
6 x 10 inches (15.2 x 25.4 cm.)
Private collection

99. PAUL SIGNAC
(French, 1863-1935)
Mont St. Michel, 1897
Oil on canvas
25 1/4 x 32 inches
(64.1 x 81.3 cm.)
Signed and dated lower right: "P
Signac 97"
DMFA 1978, no. 44.
Private collection, Dallas

100. ALFRED SISLEY
(French, 1839-1899)
The Lesson, 1871
Oil on canvas
16 1/4 x 18 1/2 inches
(41.3 x 47 cm.)
Francois Daulte. *Alfred Sisley: catalogue raisonné de l'oeuvre peint* (Lausanne, 1959) no. 19.
Private collection, Dallas

101. ALFRED SISLEY
(French, 1839-1899)
Street in Ville d'Avray, 1873
Oil on canvas
22 x 18 1/2 inches (55.9 x 47 cm.)
Signed and dated lower right:
"Sisley 73"
Daulte, no. 204.
DMFA 1978, no. 15.
Private collection, Dallas

102. ALFRED SISLEY
(French, 1839-1899)
Garden Path in Louveciennes, 1873
Oil on canvas
25 3/8 x 18 1/8 inches
(64 x 46 cm.)
Signed and dated lower left:
"Sisley '73"
Daulte, no. 146.
Private collection, Dallas

103. ALFRED SISLEY
(French, 1839-1899)
The Flood, Bank of the Seine in Autumn, 1876
Oil on canvas
19 1/4 x 25 1/2 inches
(49 x 65 cm.)
Signed and dated lower center:
"Sisley, 76"
Daulte, Catalogue raisonné supplement (in preparation).
Private collection, Dallas

104. ALFRED SISLEY
(French, 1839-1899)
The Seine at Billancourt, 1877-1878
Oil on canvas
14 3/4 x 21 1/4 inches
(37.5 x 54 cm.)
Signed lower right: "Sisley"
Private collection

105. ALFRED SISLEY
(French, 1839-1899)
The Abandoned House,
ca. 1886-1887
Oil on canvas
14 3/16 x 21 1/4 inches
(36 x 54 cm.)
Signed at lower right: "Sisley"
Daulte, no. 652.
DMFA 1978, no. 18.
Private collection, Dallas

106. NIKOLAI SUETIN
(Russian, 1897-1954)
Suprematism, 1924
Gouache and collage on paper
11 1/4 x 9 inches (28.5 x 22.9 cm.)
Dated lower right in pencil
Private collection, Dallas

107. MAURICE UTRILLO
(French, 1883-1955)
The Road to Puteaux, ca. 1915
Oil on canvas
23 3/4 x 32 1/4 inches
(61 x 82 cm.)
Signed lower right: "Maurice Utrillo. V."
Paul Petrides. *L'oeuvre complet de Maurice Utrillo* (Paris, 1959) vol. II, no. 472.
Private collection

108. SUZANNE VALADON
(French, 1867-1938)
Vase of Flowers, 1918
Oil on canvas
20 3/4 x 14 1/2 inches
(52.5 x 37 cm.)
Signed and dated upper right:
"Suzanne Valadon/1918"
Private collection, Dallas

109. SUZANNE VALADON
(French, 1867-1956)
Fruit and Flowers, 1926
Oil on canvas
19 3/4 x 25 1/2 inches
(50 x 65 cm.)
Signed and dated lower right:
"Suzanne Valadon/1926"
Paul Petrides. *L'oeuvre complet de Suzanne Valadon*
(Paris, 1971) no. 319.
Private collection, Dallas

110. GEORGES VALMIER
(French, 1885-1937)
Still Life #4, 1922
Oil on canvas
21 x 18 inches (53.3 x 45.7 cm.)
Signed and dated lower right:
"G. Valmier 1922"
Inscribed on reverse: "G. Valmier/no. 4 nature morte"
Private collection, Dallas

111. LOUIS VALTAT
(French, 1869-1952)
River Barges, 1907
Oil on board
21 1/4 x 25 1/4 inches
(53.9 x 64.7 cm.)
Signed lower right: "L. Valtat"
DMFA 1978, no. 58
Private collection, Dallas

112. GEORGES VANTONGERLOO
(Dutch, 1886-1965)
Formes, 1939
Oil on masonite
23 5/8 x 14 1/2 inches
(60 x 72.4 cm.)
Private collection, Dallas

113. MAURICE VLAMINCK
(French, 1876-1958)
The Seine at Chatou, 1906
Oil on canvas
23 1/4 x 28 1/2 inches
(60 x 72.4 cm.)
Signed at lower left: "Vlaminck"
Private collection

114. MAURICE VLAMINCK
(French, 1876-1958)
The Village, ca. 1910
Oil on canvas
28 x 35 inches (71 x 89 cm.)
Signed lower left: "Vlaminck"
Private collection, Dallas

115. EDOUARD VUILLARD
(French, 1868-1940)
Place Vintimille (triptych),
1906-1908
Pastel on cardboard, laid on wood
Left panel: 72 7/8 x 26 3/4 inches
(185.2 x 68 cm.); center panel:
74 3/8 x 19 3/8 inches (188.8 x
49.2 cm.); right panel: 72 7/8 x
26 3/4 inches (185.2 x 68 cm.)
Estate stamp on each panel lower right: "E. Vuillard"
Private collection, Dallas

116. EDOUARD VUILLARD
(French, 1868-1940)
Landscape, ca. 1920
Oil on cardboard, mounted on panel
8 3/4 x 11 inches (22.3 x 28 cm.)
Signed lower left: "E. Vuillard"
Private collection, Dallas

In all works height precedes width. Bibliographic references include only catalogues raisonné and the DMFA 1978 exhibition catalogue; they are cited completely in the first instance and in short form thereafter.

1. FREDERIC BAZILLE
(French, 1841-1871)
Portrait of Paul Verlaine as a Troubadour,
1868
Oil on canvas
18 1/16 x 15 inches (47.9 x 38.1 cm.)
Signed and dated lower right: "F. Bazille
68" (same on verso)
Foundation for the Arts Collection, Mrs.
John B. O'Hara Fund and a gift from
Colonel C. Michael Paul
1978.68 FA

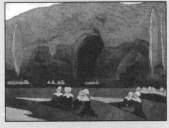

2. EMILE BERNARD
(French, 1868-1941)
Breton Women at Prayer, 1892
Oil on cardboard
32 3/8 x 45 3/4 inches (82.5 x 116.2 cm.)
Signed and dated lower right: "Emile
Bernard 1892"
The Art Museum League Fund
1963.34

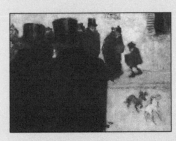

3. PIERRE BONNARD
(French, 1867-1947)
The Street in Winter, 1894
Oil on wood panel
10 1/2 x 13 3/4 inches (26.7 x 34.9 cm.)
The Wendy and Emery Reves Collection
1985.R.5

4. PIERRE BONNARD
(French, 1867-1947)
Interior: The Terrasse Children, 1899
Oil on paper board panel
12 3/8 x 21 1/8 inches (31.4 x 53.7 cm.)
The Wendy and Emery Reves Collection
1985.R.4

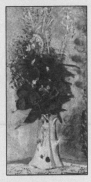

5. PIERRE BONNARD
(French, 1867-1947)
Vase of Flowers, ca. 1935
Oil on canvas
37 x 17 1/2 inches (94 x 44.5 cm.)
Signed lower right: "Bonnard"
The Wendy and Emery Reves Collection
1985.R.3

6. PIERRE BONNARD
(French, 1867-1947)
Still Life: Cherries, ca. 1942
Oil on wood panel
5 3/8 x 8 1/8 inches (13.6 x 20.7 cm.)
The Wendy and Emery Reves Collection
1985.R.2

7. EUGENE BOUDIN
(French, 1824-1898)
The Quay at Antwerp, 1874
Oil on panel
13 3/4 x 25 3/16 inches (35 x 64 cm.)
Signed and dated lower left: "E. Boudin -
Anvers - 71"
Gift of the Meadows Foundation
Incorporated
1981.102

8. ANTOINE CALBET
(French, 1860-1944)
Woman Reclining on a Bed
Watercolor
4 x 8 3/4 inches (10.2 x 22.1 cm.)
The Wendy and Emery Reves Collection
1985.R.6

9. PAUL CEZANNE
(French, 1839-1906)
Portrait of the Artist's Father, 1878-1879
Charcoal
9 5/8 x 10 3/8 inches (24.4 x 26.3 cm.)
The Wendy and Emery Reves Collection
1985.R.13

10. PAUL CEZANNE
(French, 1839-1906)
The Water Can, ca. 1879-1880
Oil on canvas
10 1/2 x 13 3/4 inches (26.7 x 34.9 cm.)
The Wendy and Emery Reves Collection
1985.R.10

11. PAUL CEZANNE
(French, 1839-1906)
House in the Country near Aix, ca. 1885-1887
Oil on canvas
25 5/8 x 32 3/8 inches (65 x 82.2 cm.)
The Wendy and Emery Reves Collection
1985.R.11

12. PAUL CEZANNE
(French, 1839-1906)
Still Life with Apples on a Sideboard,
1902-1906
Watercolor
19 1/8 x 24 7/8 inches (48.5 x 63.2 cm.)
The Wendy and Emery Reves Collection
1985.R.12

13. JEAN-BAPTISTE CAMILLE COROT
(French, 1796-1875)
Palleul, Boater in the Marshes, 1870
Oil on canvas
10 x 22 inches (25.4 x 55.8 cm.)
Signed lower right: "Corot"
Munger Fund
1960.158 M

14. GUSTAVE COURBET
(French, 1819-1877)
Portrait of the Artist's Father, ca. 1874
Watercolor and pencil
4 inches square (10.2 cm. square) - Framed
in circle, art is square
The Wendy and Emery Reves Collection
1985.R.19

15. GUSTAVE COURBET
(French, 1819-1877)
Study of the Hand
Pencil and watercolor
8 1/4 x 11 7/16 inches (21 x 29 cm.)
The Wendy and Emery Reves Collection
1985.R.20

16. GUSTAVE COURBET
(French, 1819-1877)
Portrait of Jongkind
Gouache
8 1/4 x 6 5/8 inches (20.8 x 16.7 cm.)
The Wendy and Emery Reves Collection
1985.R.21

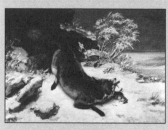

17. GUSTAVE COURBET
(French, 1819-1877)
Fox in the Snow, 1860
Oil on canvas
33 3/4 x 50 1/16 inches (85.7 x 127.8 cm.)
Signed and dated lower left: "Gustave
Courbet 1860"
Foundation for the Arts Collection, Mrs.
John B. O'Hara Fund
1979.7 FA

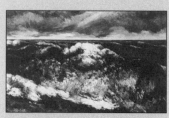

18. GUSTAVE COURBET
(French, 1819-1877)
The Angry Sea, ca. 1869-1870
Oil on canvas
22 x 36 inches (55.9 x 91.4 cm.)
Signed lower left: "G. Courbet"
Gift of H.J. Rudick in memory of Arthur
L. Kramer
1950.86

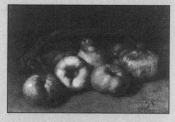

19. GUSTAVE COURBET
(French, 1819-1877)
*Still Life with Apples, Pear, and
Pomegranates*, 1871 or 1872
Oil on canvas
10 3/4 x 16 1/4 inches (27.3 x 41.2 cm.)
Signed lower right: "G.C./Ste Pélagie"
The Wendy and Emery Reves Collection
1985.R.18

20. HONORE DAUMIER
(French, 1808-1879)
Study of an Actor
Pen and wash on paper
9 3/4 x 6 5/8 inches (24.8 x 16.8 cm.)
The Wendy and Emery Reves Collection
1985.R.23

21. HONORE DAUMIER
(French, 1808-1879)
Outside the Print-Seller's Shop, ca. 1860-1863
Oil on panel
19 1/2 x 15 3/4 inches (49.5 x 40 cm.)
Foundation for the Arts Collection, Mrs.
John B. O'Hara Fund
1981.33 FA

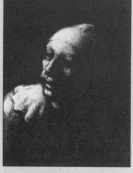

22. HONORE DAUMIER
(French, 1808-1879)
Head of Pasquin, 1862-1863
Oil on wood panel
8 7/8 x 6 7/8 inches (22.5 x 17.5 cm.)
The Wendy and Emery Reves Collection
1985.R.22

23. EDGAR DEGAS
(French, 1834-1917)
Aria after the Ballet, 1879
Pastel over peinture à l'essence on paper
23 1/2 x 29 1/2 inches (59.7 x 75 cm.)
Signed lower right: "Degas"
The Wendy and Emery Reves Collection
1985.R.26

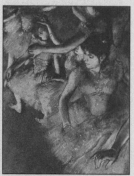

24. EDGAR DEGAS
(French, 1834-1917)
Ballet Dancers on the Stage, 1883
Pastel on paper
24 1/2 x 18 5/8 inches (62.2 x 47.3 cm.)
Signed lower left: "Degas"
Gift of Mr.and Mrs. Franklin B. Bartholow
1986.277

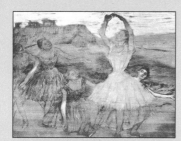

25. EDGAR DEGAS
(French, 1834-1917)
Ballet Dancers in an Antique Setting,
ca. 1890-1895
Pastel on wood
12 1/2 x 16 inches (31.7 x 40.6 cm.)
The Wendy and Emery Reves Collection
1985.R.25

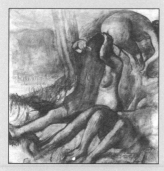

26. EDGAR DEGAS
(French, 1834-1917)
The Bathers, ca. 1890-1895
Pastel and charcoal on tracing paper
42 15/16 x 43 3/4 inches (109 x 111 cm.)
Stamped signature at lower left: "Degas"
The Wendy and Emery Reves Collection
1985.R.24

27. ROBERT DELAUNAY
(French, 1885-1941)
Eiffel Tower, 1924
Oil on canvas
72 1/2 x 68 1/2 inches (184.2 x 174 cm.)
Gift of the Meadows Foundation
Incorporated
1981.105

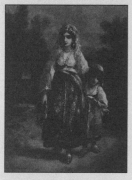

28. NARCISSE DIAZ DE LA PEÑA
(French, 1807-1876)
Woman and Girl, 1861
Oil on panel
15 3/4 x 12 inches (40 x 30.4 cm.)
Gift of Mrs. Leslie Waggener in memory
of Leslie Waggener
1955.26

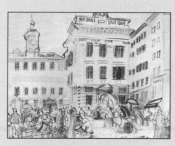

29. RAOUL DUFY
(French, 1877-1953)
Cafe Marocain, 1940
Watercolor
19 x 25 inches (48.3 x 63.5 cm.)
Gift of the Meadows Foundation
Incorporated
1981.107

30. RAOUL DUFY
(French, 1877-1953)
Collioure, 1941
Watercolor
18 3/4 x 24 3/4 inches (47.6 x 62.8 cm.)
Gift of the Meadows Foundation
Incorporated
1981.108

31. Imitator of HENRI FANTIN-
LATOUR (French, 1836-1904)
Fall Flowers, 1863
Oil on canvas
19 x 17 inches (48.2 x 43.2 cm.)
Gift of Mr. and Mrs. James H. Clark
R.1965.01

32. Imitator of HENRI FANTIN-
LATOUR (French, 1836-1904)
Spring Flowers, 1863
Oil on canvas
18 3/4 x 16 1/2 inches (47.7 x 41.9 cm.)
Gift of Mr. and Mrs. James H. Clark
R.1965.02

33. HENRI FANTIN-LATOUR
(French, 1836-1904)
Portrait of Manet, ca. 1867
Ink
6 3/16 x 6 1/8 inches (13.1 x 13 cm.)
Signed lower left: "Fantin"
The Wendy and Emery Reves Collection
1985.R.27

34. HENRI FANTIN-LATOUR
(French, 1836-1904)
Flowers and Grapes, 1875
Oil on canvas
17 15/16 x 21 inches (45.7 x 53.3 cm.)
Gift of the Meadows Foundation
Incorporated
1981.116

35. PAUL GAUGUIN
(French, 1848-1903)
Portrait of the Artist's Uncle with a Hat,
ca. 1884
Oil on canvas
10 3/4 x 7 3/8 inches (27.3 x 18.7 cm.)
The Wendy and Emery Reves Collection
1985.R.29

36. PAUL GAUGUIN
(French, 1848-1903)
I Raro Te Oviri (Under the Pandanus), 1891
Oil on canvas
26 1/2 x 35 1/2 inches (68 x 90 cm.)
Signed and dated lower left: "P. Gauguin
91"
Foundation for the Arts Collection, gift of
Adele R. Levy Fund, Inc. New York
1963.58 FA

37. NATALIA SERGEEVNA
GONCHAROVA
(Russian, 1881-1962)
Maquillage, 1913-1914
Gouache on paper
6 3/8 x 4 3/4 inches (16.2 x 12 cm.)
General Acquisitions Fund
1981.37

38. RUDOLF JAHNS
(German, 1896-1983)
Composition with Two White Segments, 1925
Tempera on cardboard, mounted on panel
13 x 14 11/16 inches (33 x 37.3 cm.)
General Acquisitions Fund
1977.06

39. JOHAN BARTHOLD JONGKIND
(Dutch, 1819-1891)
Rouen, 1864
Watercolor and charcoal
12 5/16 x 12 9/16 inches (31.3 x 32 cm.)
The Wendy and Emery Reves Collection
1985.R.30

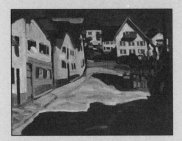

40. WASSILY KANDINSKY
(Russian, 1866-1944)
Houses in Murnau, 1909-1910
Oil on paper mounted on masonite
19 7/8 x 25 inches (50.5 x 63.5 cm.)
Dallas Art Association purchase
1963.31

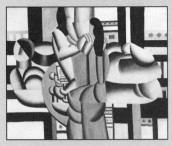

41. FERNAND LEGER
(French, 1881-1955)
Three Women and Still-Life, 1920
Oil on canvas
28 3/4 x 36 1/4 inches (73 x 92.1 cm.)
Signed and dated lower right: "F. Leger-20"
Foundation for the Arts Collection, gift of
the James H. and Lillian Clark Foundation
1982.27 FA

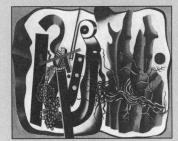

42. FERNAND LEGER
(French, 1881-1955)
Composition with Tree Trunks, 1933
Oil on canvas
51 1/2 x 64 inches (130.8 x 162.6 cm.)
Signed and dated lower right:
"F. Leger/33"
Foundation for the Arts Collection, gift of
the James H. and Lillian Clark Foundation
1982.28 FA

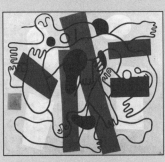

43. FERNAND LEGER
(French, 1881-1955)
The Divers (Red and Black), 1942
Oil on canvas
50 1/8 x 58 1/8 inches (127.3 x 147.7 cm.)
Signed and dated lower right:
"42/F. Leger"
Foundation for the Arts Collection, gift of
the James H. and Lillian Clark Foundation
1982.29 FA

44. MAX LIEBERMAN
(German, 1847-1935)
Swimming, 1875-1878
Oil on canvas
71 1/4 x 88 5/8 inches (181 x 225.1 cm.)
Signed lower left: "M. Lieberman"
Foundation for the Arts Collection, Mrs.
John B. O'Hara Fund
1988.16 FA

45. MAXIMILIEN LUCE
(French, 1858-1941)
The Thames at Vauxhall Bridge
Charcoal on paper
7 11/16 x 9 3/4 inches (19.5 x 25 cm.)
The Wendy and Emery Reves Collection
1985.R.31

46. RENE MAGRITTE
(Belgian, 1898-1967)
The Light of Coincidences, 1933
Oil on canvas
23 5/8 x 28 3/4 inches (60 x 73 cm.)
Signed lower right: "Magritte"
Gift of Mr. and Mrs. Jake L. Hamon
1981.9

47. RENE MAGRITTE
(Belgian, 1898-1967)
Persian Letters, 1958
Oil on canvas
16 x 12 inches (40.6 x 30.5 cm)
Gift of J.B. Adoue, III
1987.480

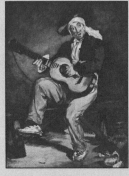

48. EDOUARD MANET
(French, 1832-1883)
The Spanish Singer, ca. 1861
Watercolor on paper
11 x 8 3/4 inches (28 x 22.2 cm.)
Signed lower right: "Manet"
The Wendy and Emery Reves Collection
1985.R.33

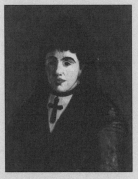

49. EDOUARD MANET
(French, 1832-1883)
Spanish Woman Wearing a Black Cross, 1865
Oil on canvas
24 x 18 1/2 inches (61 x 47 cm.)
The Wendy and Emery Reves Collection
1987.R.1123

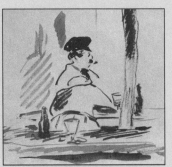

50. EDOUARD MANET
(French, 1832-1883)
Le Bouchon, ca. 1878
Wash and pencil
8 1/4 x 11 1/8 inches (21 x 28.3 cm.)
Signed at right: "E.M."
The Wendy and Emery Reves Collection
1985.R.35

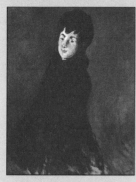

51. EDOUARD MANET
(French, 1832-1883)
Portrait of Isabelle Lemonnier, ca. 1879
Oil on canvas
36 x 28 3/4 inches (91.4 x 73 cm.)
Gift of Mr. and Mrs. Algur H. Meadows
and the Meadows Foundation
Incorporated
1978.1

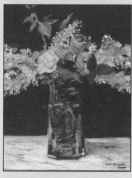

52. EDOUARD MANET
(French, 1832-1883)
Portrait of Juilette Dodu, ca. 1880
Pen and ink on paper
8 5/16 x 6 5/8 inches (21.1 x 16.8 cm.)
Signed lower right: "E.M."
The Wendy and Emery Reves Collection
1985.R.32

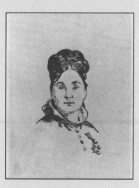

53. EDOUARD MANET
(French, 1832-1883)
Vase of White Lilacs and Roses, 1883
Oil on canvas
22 x 18 1/8 inches (55.9 x 46 cm.)
Signed lower right: "Manet"
The Wendy and Emery Reves Collection
1985.R.34

54. ALBERT MARQUET
(French, 1875-1947)
The Beach at Trouville, ca. 1906
Oil on canvas
21 x 25 1/2 (53.3 x 64.8 cm.)
Signed lower left: "Marquet"
Gift of the Meadows Foundation
Incorporated
1981.121

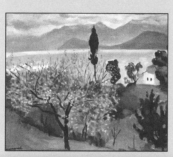

55. ALBERT MARQUET
(French, 1875-1947)
Flowering Trees
Oil on canvas
19 3/4 x 24 inches (50.2 x 61 cm.)
Signed lower left: "Marquet"
Gift of the Meadows Foundation
Incorporated
1981.122

56. ALBERT MARQUET
(French, 1875-1947)
The Red Roofs, 1924
Oil on canvas
23 1/2 x 31 7/8 inches (59.7 x 81 cm.)
Signed lower right: "Marquet"
Gift of the Meadows Foundation
Incorporated
1981.123

57. ALBERT MARQUET
(French, 1875-1947)
Rising Sun over the Port of Algers, 1945
Oil on canvas
28 5/8 x 31 7/8 inches (72.7 x 81 cm.)
Signed lower right: "Marquet"
Gift of Nicholas Acquavella
1978.94

58. HENRI MATISSE
(French, 1869-1954)
Ivy in Flower, 1953
Colored paper and pencil
112 x 112 inches (284.5 x 284.5 cm.)
Foundation for the Arts Collection, gift of
the Albert and Mary Lasker Foundation
1963.68 FA

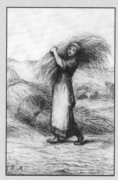

59. JEAN FRANCOIS MILLET
(French, 1814-1875)
Harvest Scene, ca. 1860
Charcoal
10 x 7 5/16 inches (25.4 x 19.3 cm.)
Signed with monogram lower left:
"J.F.M."
The Wendy and Emery Reves Collection
1985.R.37

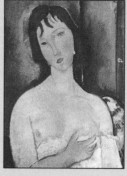

60. AMEDEO MODIGLIANI
(Italian, 1884-1920)
Portrait of a Young Woman, 1916-1919
Oil on canvas
25 1/2 x 19 3/4 inches (64.8 x 50.2 cm.)
Signed upper right: "Modigliani"
Gift of the Meadows Foundation
Incorporated
1981.126

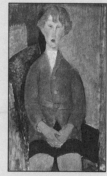

61. AMEDEO MODIGLIANI
(Italian, 1884-1920)
Boy in Short Pants, ca. 1918
Oil on canvas
39 1/2 x 25 1/2 inches (100.3 x 64.8 cm.)
Signed upper right: "Modigliani"
Gift of the Leland Fikes Foundation, Inc.
1977.1

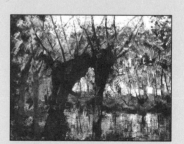

62. PIET MONDRIAN
(Dutch, 1872-1944)
The River Gein, ca. 1903
Oil on canvas
13 13/16 x 17 7/8 inches (35.1 x 45.4 cm.)
Signed lower left: "PIET MONDRIAN"
Foundation för the Arts Collection, gift of
Mr. and Mrs. James H. Clark
1975.65 FA

82

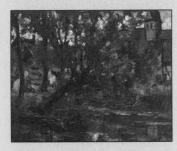

63. PIET MONDRIAN
(Dutch, 1872-1944)
Brabant Landscape, ca. 1904
Oil on canvas
15 1/2 x 19 3/4 inches (39.4 x 50.2 cm.)
Gift of Mr. and Mrs. James H. Clark
R.1966.1

64. PIET MONDRIAN
(Dutch, 1872-1944)
Trees on the Gein, ca. 1906
Watercolor on paper
11 11/16 x 15 5/8 inches (30.3 x 39.7 cm.)
Signed lower right: "PIET MONDRIAN"
Foundation for the Arts Collection, gift of
Mr. and Mrs. James H. Clark
1975.66 FA

65. PIET MONDRIAN
(Dutch, 1872-1944)
Windmill in the Sunlight II, ca. 1908
Oil on canvas
17 1/4 x 13 1/2 inches (43.8 x 34.3 cm.)
Signed lower right: "Piet Mondriaan"
Foundation for the Arts Collection, gift of
the James H. and Lillian Clark Foundation
1982.25 FA

66. PIET MONDRIAN
(Dutch, 1872-1944)
Castle Ruin: Brederode, 1908
Oil on composition board
24 1/2 x 28 1/2 inches (62.2 x 72.4 cm.)
Signed lower right: "Piet Mondrian"
Foundation for the Arts Collection, gift of
the James H. and Lillian Clark Foundation
1982.24 FA

67. PIET MONDRIAN
(Dutch, 1872-1944)
Farm Near Duivendrecht, 1908-1909
Oil on canvas
31 1/2 x 41 3/4 inches (80 x 106.6 cm.)
Signed lower right: "P. Mondriaan"
Gift of the Edward and Betty Marcus
Foundation
1987.359

68. PIET MONDRIAN
(Dutch, 1872-1944)
Blue Tree, ca. 1909-1910
Oil on composition board
22 3/8 x 29 1/2 inches (56.8 x 74.9 cm.)
Signed lower right with monogram: "PM"
Foundation for the Arts Collection, gift of
the James H. and Lillian Clark Foundation
1982.26 FA

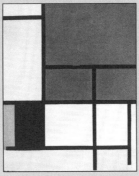

69. PIET MONDRIAN
(Dutch, 1872-1944)
Composition with Great Blue Plane, 1921
Oil on canvas
23 3/4 x 19 5/8 inches (60.3 x 49.9 cm.)
Signed and dated lower left: "PM '21"
Foundation for the Arts Collection, gift of
Mrs. James H. Clark
1984.200 FA

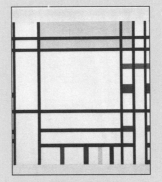

70. PIET MONDRIAN
(Dutch, 1872-1944)
Place de la Concorde, 1938-1943
Oil on canvas
37 x 37 3/16 inches (94 x 94.5 cm.)
Signed lower left with monogram: "PM";
and dated lower right: "38/43"
Foundation for the Arts Collection, gift of
the James H. and Lillian Clark Foundation
1982.22 FA

71. PIET MONDRIAN
(Dutch, 1872-1944)
Self-Portrait, 1942
Ink and charcoal on paper
25 x 19 inches (63.5 x 48.3 cm.)
Foundation for the Arts Collection, gift of
the James H. and Lillian Clark Foundation
1982.23 FA

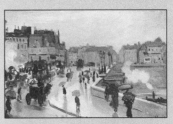

72. CLAUDE MONET
(French, 1840-1926)
The Pont Neuf, 1872
Oil on canvas
20 15/16 x 18 1/2 inches (53.1 x 72.4 cm.)
Signed lower right: "Cl. M."
The Wendy and Emery Reves Collection
1985.R.38

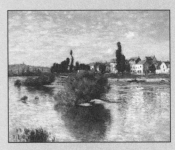

73. CLAUDE MONET
(French, 1840-1926)
The Seine at Lavacourt, 1880
Oil on canvas
38 3/4 x 58 3/4 inches (98.4 x 149.2 cm.)
Signed and dated lower left: "Claude
Monet 1880"
Munger Fund
1938.4 M

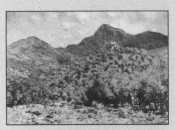

74. CLAUDE MONET
(French, 1840-1926)
Valle Buona, near Bordighera, 1884
Oil on canvas
25 3/4 x 36 1/4 inches (65.3 x 92 cm.)
Signed and dated lower right: "Claude
Monet 84"
Gift of the Meadows Foundation
Incorporated
1981.127

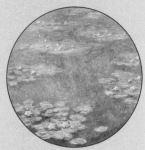

75. CLAUDE MONET
(French, 1840-1926)
Water Lilies, 1908
Oil on canvas
Dia. 31 1/2 inches (80 cm.)
Signed and dated lower right: "Claude
Monet 1908"
Gift of the Meadows Foundation
Incorporated
1981.128

76. ADOLPHE MONTICELLI
(French, 1824-1886)
Still Life with Sardines and Sea-Urchins,
1880-1882
Oil on wood panel
18 x 23 5/8 inches (45.7 x 60 cm.)
The Wendy and Emery Reves Collection
1985.R.39

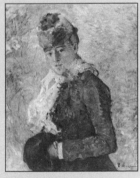

77. BERTHE MORISOT
(French, 1841-1895)
Lady with a Muff, 1880
Oil on canvas
29 x 23 inches (73.7 x 58.4 cm.)
Signed lower right: "B. Morisot"
Gift of the Meadows Foundation
Incorporated
1981.129

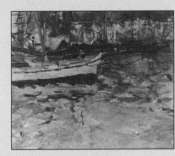

78. BERTHE MORISOT
(French, 1841-1895)
The Port of Nice, 1881-1882
Oil on canvas
15 x 18 1/4 inches (38 x 46.4 cm.)
Signed lower left: "B. Morisot"
The Wendy and Emery Reves Collection
1985.R.40

79. BEN NICHOLSON
(British, 1894-1982)
White Relief, 1936
Oil on carved board
42 x 53 1/2 inches (106.7 x 135.9 cm.)
Foundation for the Arts Collection
1963.77 FA

80. ROLAN OUDOT
(French, 1897-1981)
The Farm, 1924-1925
Oil on canvas
18 x 24 inches (44.7 x 60.9 cm.)
Gift of Mrs. Chester Dale
1963.175

81. PABLO PICASSO
(Spanish, 1881-1973)
Bust, 1907-1908
Oil on canvas
16 1/2 x 17 inches (40.9 x 42.5 cm.)
Foundation for the Arts Collection, gift of
Joshua L. Logan, Loula D. Lasker, Ruth
and Nathan Cummings Art Foundation,
Mr. and Mrs. Edward S. Marcus, Sarah
Dorsey Hudson, Mrs. Alfred L. Bromberg,
Henry Jacobus and an anonymous donor,
by exchange
1987.399 FA

82. CAMILLE PISSARRO
(French, 1830-1903)
Louveciennes, 1871
Oil on canvas
12 7/8 x 18 1/8 inches (32.7 x 47 cm.)
The Wendy and Emery Reves Collection
1985.R.42

83. CAMILLE PISSARRO
(French, 1830-1903)
Peasant Carrying Two Bales of Hay, 1883
Oil on canvas
8 7/8 x 23 5/8 inches (73.4 x 60 cm.)
Signed and dated lower left: "C. Pissarro
188(3)"?
Gift of the Meadows Foundation
Incorporated
1981.132

84. CAMILLE PISSARRO
(French, 1830-1903)
Apple Picking at Eragny-Sur-Epte, 1888
Oil on canvas
23 x 28 1/2 inches (58.4 x 72.4 cm.)
Signed and dated lower right: "C. Pissarro.
1888"
Munger Fund
1955.17 M

85. CAMILLE PISSARRO
(French, 1830-1903)
View of Eragny-Sur-Epte, 1890
Watercolor and pencil on paper
8 1/2 x 10 1/4 inches (16.5 x 26 cm.)
Signed and dated lower left: "Eragny 1890
C. Pissarro"
The Wendy and Emery Reves Collection
1985.R.48

86. CAMILLE PISSARRO
(French, 1830-1903)
Rue de l'Hermitage, Pontoise, 1873
Watercolor, pencil and possibly oil
7 1/8 x 9 9/16 inches (17.9 x 24.2 cm.)
The Wendy and Emery Reves Collection
1985.R.45

87. CAMILLE PISSARRO
(French, 1830-1903)
*Young Girl with Geese (Daphnis and Chloe
Series)*, 1895
Ink and body color on papers pieced
together
4 3/4 x 5 1/2 inches (12 x 14 cm.)
The Wendy and Emery Reves Collection
1985.R.43

88. CAMILLE PISSARRO
(French, 1830-1903)
The Harvester (Daphnis and Chloe Series),
ca. 1895
Ink and body color on papers pieced
together
4 11/16 x 5 1/4 inches (11.9 x 13.6 cm.)
Signed lower right: "C.P."
The Wendy and Emery Reves Collection
1985.R.47

89. CAMILLE PISSARRO
(French, 1830-1903)
Anarchist Meeting in the Streets, 1870-1871
Charcoal, ink wash, and gouache on paper
7 5/8 x 9 5/8 inches (19.4 x 25.4 cm.)
Signed lower left: "C.P."
The Wendy and Emery Reves Collection
1985.R.49

90. CAMILLE PISSARRO
(French, 1830-1903)
The Bathers, 1894-1895
Color monotype
4 1/2 x 6 1/4 inches (12 x 16 cm.)
The Wendy and Emery Reves Collection
1985.R.46

91. CAMILLE PISSARRO
(French, 1830-1903)
La Varenne Saint Hilaire, 1864-1865
Charcoal
12 x 18 7/16 inches (30.5 x 46.9 cm.)
The Wendy and Emery Reves Collection
1985.R.51

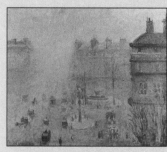

92. CAMILLE PISSARRO
(French, 1830-1903)
The Place du Théâtre Français, Foggy Day,
1897
Oil on canvas
21 3/8 x 26 inches (54.3 x 66 cm.)
Signed lower left: "C. Pissarro - 97"
The Wendy and Emery Reves Collection
1985.R.50

93. CAMILLE PISSARRO
(French, 1830-1903)
Self-Portrait, ca. 1898
Oil on canvas
20 7/8 x 12 inches (53 x 30.5 cm.)
Stamped signature lower right: "C.P."
The Wendy and Emery Reves Collection
1985.R.44

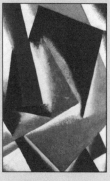

94. LIUBOV POPOVA
(Russian, 1889-1924)
Painterly Architectonics, 1918
Oil on cardboard
23 3/8 x 15 1/2 inches (59.4 x 39.4 cm.)
Signed verso: "LS Popova/1918"
General Acquisitions Fund and gifts from
Mrs. Edward Marcus, James H. Coker and
Ann Addison, Margaret Ann Bolinger,
George and Natalie H.(Schatzie) Lee, Mrs.
Elizabeth Blake and an anonymous donor.
1982.10

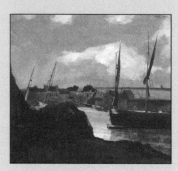

95. ODILON REDON
(French, 1840-1916)
The Port of Morgat, 1882
Oil on canvas
10 5/8 x 11 5/8 inches (27 x 29.5 cm.)
The Wendy and Emery Reves Collection
1985.R.53

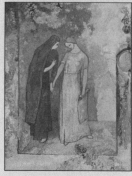

96. ODILON REDON
(French, 1840-1916)
Initiation to Study - Two Young Ladies,
ca. 1905
Oil on canvas
36 3/4 x 29 3/8 inches (93.3 x 74.6 cm.)
Signed lower left: "Odilon Redon"
Foundation for the Arts Collection,
anonymous gift
1963.80 FA

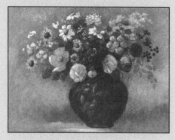

97. ODILON REDON
(French, 1840-1916)
Wild Flowers in a Vase, ca. 1910
Pastel on board
20 1/2 x 27 inches (52 x 68.5 cm.)
The Wendy and Emery Reves Collection
1985.R.54

98. ODILON REDON
(French, 1840-1916)
Flowers in a Black Vase, ca. 1909-1910
Pastel
34 3/8 x 27 inches (87.3 x 68.5 cm.)
Signed lower right: "Odlon (sic) Redon"
The Wendy and Emery Reves Collection
1985.R.55

99. PIERRE-AUGUSTE RENOIR
(French, 1841-1919)
Lise Sewing, 1866
Oil on canvas
22 x 18 inches (55.9 x 45.7 cm.)
Signed lower left: "A. Renoir"
The Wendy and Emery Reves Collection
1985.R.59

100. PIERRE-AUGUSTE RENOIR
(French, 1841-1919)
*The Stolen Kiss (Jules Le Coeur and
Cleménce Tréhot),* 1866-1867
Watercolor over pencil
9 15/16 x 6 15/16 inches (25.3 x 17.7 cm.)
Signed lower right: "A. Renoir"
The Wendy and Emery Reves Collection
1985.R.61

101. PIERRE-AUGUSTE RENOIR
(French, 1841-1919)
Lise in a White Shawl, 1872
Oil on canvas
22 x 18 inches (55.9 x 45.7 cm.)
The Wendy and Emery Reves Collection
1985.R.58

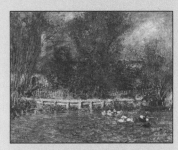

102. PIERRE-AUGUSTE RENOIR
(French, 1841-1919)
The Duck Pond, 1873
Oil on canvas
19 3/4 x 24 inches (50.2 x 61 cm.)
Signed lower left: "Renoir"
The Wendy and Emery Reves Collection
1985.R.56

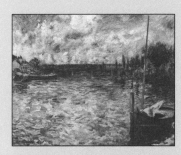

103. PIERRE-AUGUSTE RENOIR
(French, 1841-1919)
The Seine at Chatou, 1874
Oil on canvas
20 x 25 inches (50.8 x 63.5 cm.)
The Wendy and Emery Reves Collection
1985.R.62

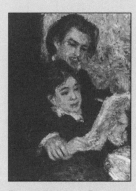

104. PIERRE-AUGUSTE RENOIR
(French, 1841-1919)
Rivière and Margot, 1876
Oil on canvas
13 5/8 x 10 inches (34.6 x 25.4 cm.)
The Wendy and Emery Reves Collection
1985.R.60

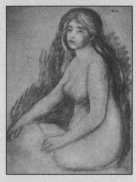

105. PIERRE-AUGUSTE RENOIR
(French, 1841-1919)
Bather, 1881
Red chalk on tracing paper
33 1/4 x 25 13/16 inches (84.5 x 65.5 cm.)
The Wendy and Emery Reves Collection
1985.R.57

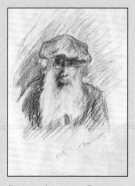

106. PIERRE-AUGUSTE RENOIR
(French, 1841-1919)
Portrait of Pissarro, ca. 1898-1903
Charcoal on paper
12 x 9 1/2 inches (30.5 x 24 cm.)
The Wendy and Emery Reves Collection
1985.R.63

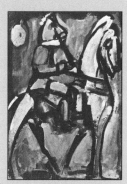

107. GEORGES ROUAULT
(French, 1871-1958)
The Horseman , ca. 1928-1929
Oil on canvas
28 3/4 x 20 1/2 inches (73 x 52 cm.)
Signed lower right: "G. Rouault"
Dallas Museum of Art, gift of the
Meadows Foundation Incorporated
1981.134

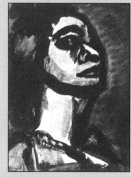

108. GEORGES ROUAULT
(French, 1871-1958)
The Clowness, 1932
Gouache on paper on canvas
10 x 8 inches
Gift of Kay Lee Wrage Gunn in memory of
Irma Wrage Hendrickson
1980.48

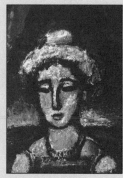

109. GEORGES ROUAULT
(French, 1871-1958)
The Italian Woman, 1938
Oil on panel
31 1/8 x 25 1/4 inches (79 x 64.1 cm.)
Dallas Museum of Art, gift of Mr. and Mrs.
Vladimir Horowitz
1976.53

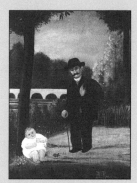

110. HENRI ROUSSEAU
(French, 1844-1910)
Stroller and Child, 1905-1906
Oil on canvas
21 5/8 x 15 1/4 inches (54.9 x 38.7 cm.)
Signed lower right: "H. Rousseau"
Foundation for the Arts Collection,
anonymous gift
1963.83 FA

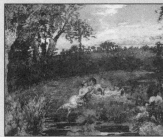

111. KER XAVIER ROUSSEL
(French, 1867-1944)
Lovers on the Riverbank, ca. 1910-1920
Pastel and watercolor on paperboard
25 3/4 x 32 1/8 inches (65.4 x 81.6 cm.)
The Roberta Coke Camp Fund
1988.11

114. GEORGES SEURAT
(French, 1859-1891)
Grassy Riverbank, 1881-1882
Oil on canvas
12 3/4 x 16 inches (32.5 x 40.7 cm.)
The Wendy and Emery Reves Collection
1985.R.68

117. HENRI DE TOULOUSE-LAUTREC
(French, 1864-1901)
Bouquet of Violets, 1882
Oil on wood panel
9 3/8 x 7 3/8 inches (23.8 x 18.8 cm.)
The Wendy and Emery Reves Collection
1985.R.77

120. VINCENT VAN GOGH
(Dutch, 1853-1890)
Riverbank in Springtime, 1887
Oil on canvas
19 3/8 x 22 3/8 inches (49.2 x 57.8 cm.)
The Eugene and Margaret McDermott
Fund in memory of Arthur Berger
1961.99 McD

112.. KER XAVIER ROUSSEL
(French, 1867-1944)
Bathers, ca. 1903
Pastel and watercolor on paperboard
17 1/2 x 17 7/8 inches (44.5 x 45.4 cm.)
The Roberta Coke Camp Fund
1988.12

115. ALFRED SISLEY
(French, 1839-1899)
Road Along the Water at Saint-Mammès,
ca. 1879-1880
Oil on canvas
29 x 21 3/8 inches (73.7 x 54.3 cm.)
Signed lower right: "Sisley"
The Wendy and Emery Reves Collection
1985.R.69

118. HENRI DE TOULOUSE-LAUTREC
(French, 1864-1901)
Femmes de Maison, ca. 1893-1895
Pastel on emery cloth
24 x 19 5/8 inches (61 x 49.9 cm.)
The Wendy and Emery Reves Collection
1985.R.75

121. VINCENT VAN GOGH
(Dutch, 1853-1890)
Cafe Terrace at Night, 1888
Reed pen and ink over pencil
24 5/8 x 18 3/4 inches (61.6 x 47.6 cm.)
The Wendy and Emery Reves Collection
1985.R.79

113. PAUL SERUSIER
(French, 1863-1927)
Celtic Tale, 1894
Oil on canvas
43 5/8 x 39 3/4 inches (110.4 x 99.1 cm.)
Signed lower left: "P Serusier/94"
Foundation for the Arts Collection, gift of
Mr. and Mrs. Frederick Mayer
1983.52 FA

116. HENRI DE TOULOUSE-LAUTREC
(French, 1864-1901)
Dog, 1880
Oil on canvas
5 1/4 x 9 inches (13.4 x 22.9 cm.)
The Wendy and Emery Reves Collection
1985.R.78

122. VINCENT VAN GOGH
(Dutch, 1853-1890)
Sheaves of Wheat, 1890
Oil on canvas
19 7/8 x 39 3/4 inches (50.5 x 101 cm.)
The Wendy and Emery Reves Collection
1985.R.80

119. HENRI DE TOULOUSE-LAUTREC
(French, 1864-1901)
The Last Respects, 1887
Ink and gouache on paper
25 3/4 x 19 3/8 inches (65.5 x 49.2 cm.)
Signed lower right with anagram: "H
Treclau"
The Wendy and Emery Reves Collection
1985.R.76

123. MAURICE VLAMINCK
(French, 1876-1958)
Bougival, ca. 1905
Oil on canvas
32 1/2 x 39 5/8 inches (82.5 x 100.7 cm.)
Signed lower left: "Vlaminck"
The Wendy and Emery Reves Collection
1985.R.

126. EDOUARD VUILLARD
(French, 1868-1940)
Two Studies for The Tent, 1908
Pencil
Top sheet: 3 1/8 x 5 1/4 inches (8 x 13.3
cm.); bottom sheet: 3 1/8 x 3 11/16 inches
(8 x 9.5 cm.)
Signed lower right: "E.V."
The Wendy and Emery Reves Collection
1985.R.84

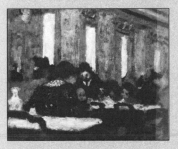

124. EDOUARD VUILLARD
(French, 1868-1940)
The Little Restaurant, 1894
Oil on paper board panel
11 3/8 x 9 inches (28.9 x 22.8 cm.)
The Wendy and Emery Reves Collection
1985.R.85

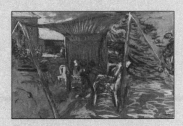

127. EDOUARD VUILLARD
(French, 1868-1940)
The Tent, 1908
Distemper on paper mounted on canvas
29 1/2 x 44 1/4 inches (75 x 112.5 cm.)
The Wendy and Emery Reves Collection
1985.R.83

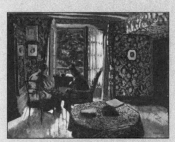

125. EDOUARD VUILLARD
(French, 1868-1940)
Interior, ca. 1902
Oil on cardboard
20 1/8 x 26 3/8 inches (51 x 67 cm.)
Signed lower right: "E Vuillard"
Dallas Museum of Art, gift of the
Meadows Foundation Incorporated
1981.137